MANDALAS & CHAKRAS
50 CREATIVE ILLUSTRATIONS
BY SERENA KING

All rights reserved. This book or any portion thereof may not be reproduced or used in any manner whatsoever without the written permission of the artist.

Mandalas & Chakras adult coloring book has 50 creative mandala illustrations including the seven chakras, four elements (earth, water, air, and fire), sun, moon, symbol art, and more! Ultimately, it is our sincere hope that this coloring book will inspire, calm, and center you. Namaste.

To keep up-to-date with the new adult coloring books as they become available, or purchase print it yourself PDF digibooks, we invite you to check out https://serenaking.com/adult-coloring-books.

Seven Chakra Mandala

Starting with the root chakra in the center,
and the crown chakra being the outer layer.

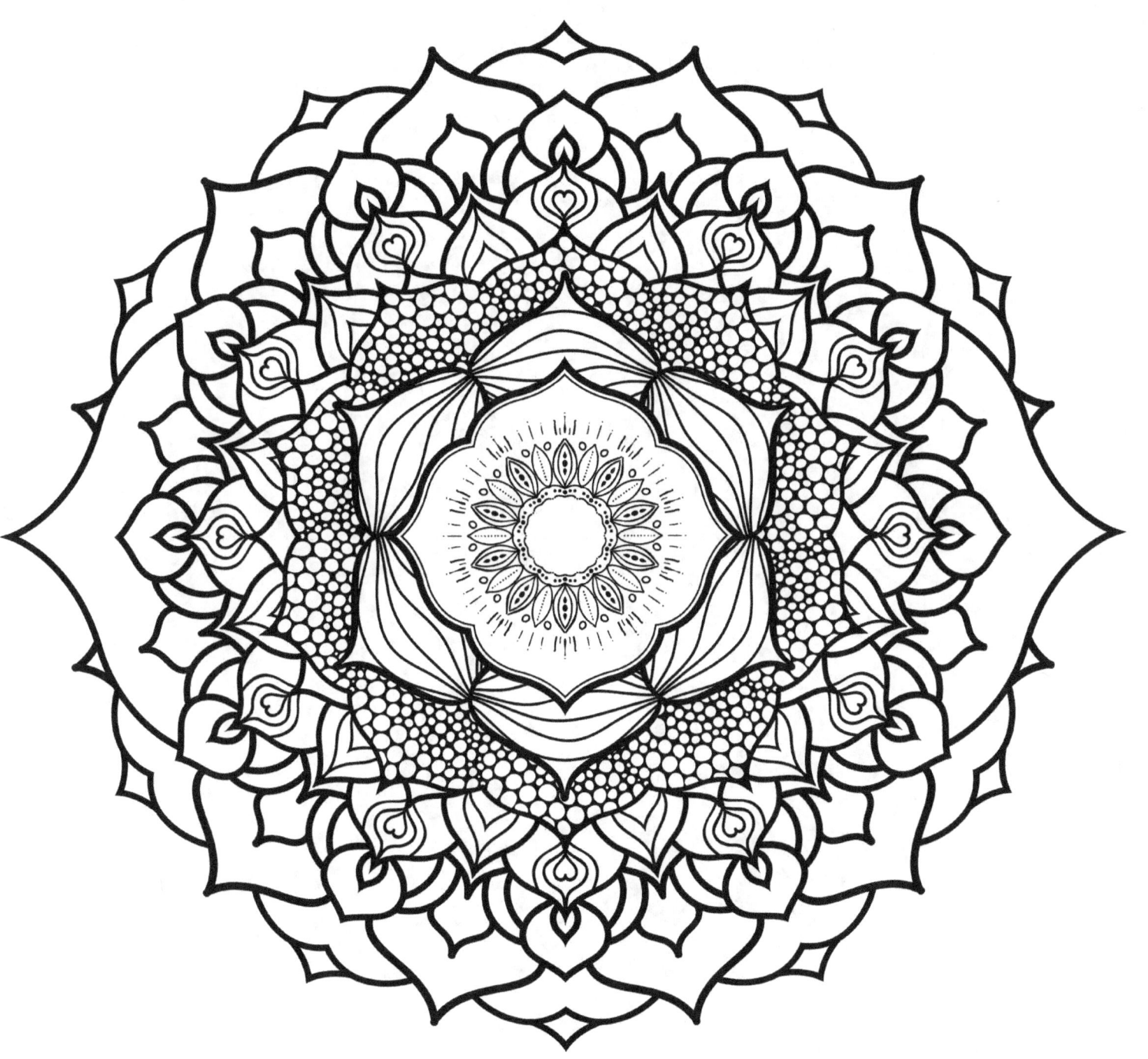

Crown Chakra Mandala

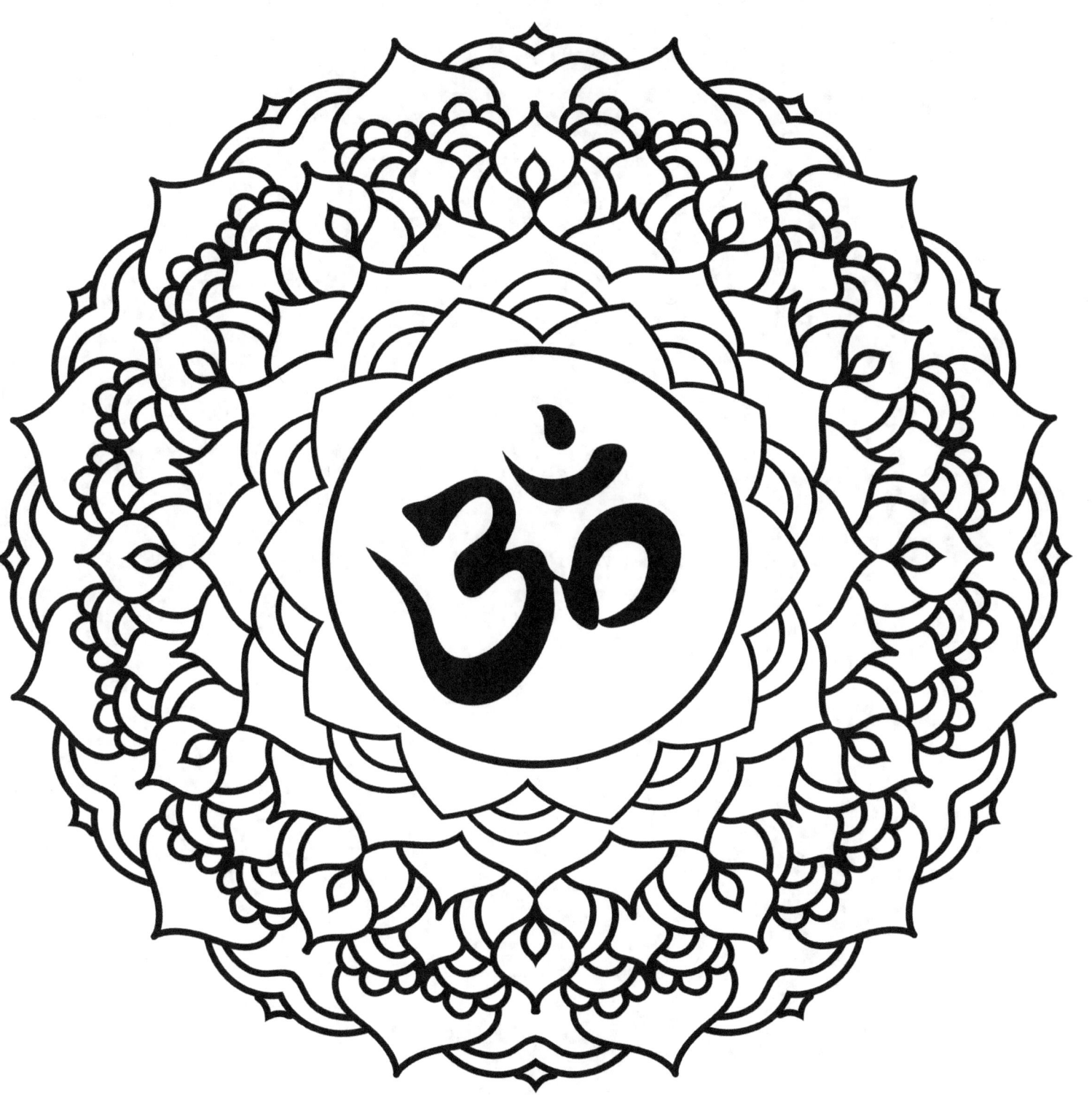

Third Eye Chakra Mandala

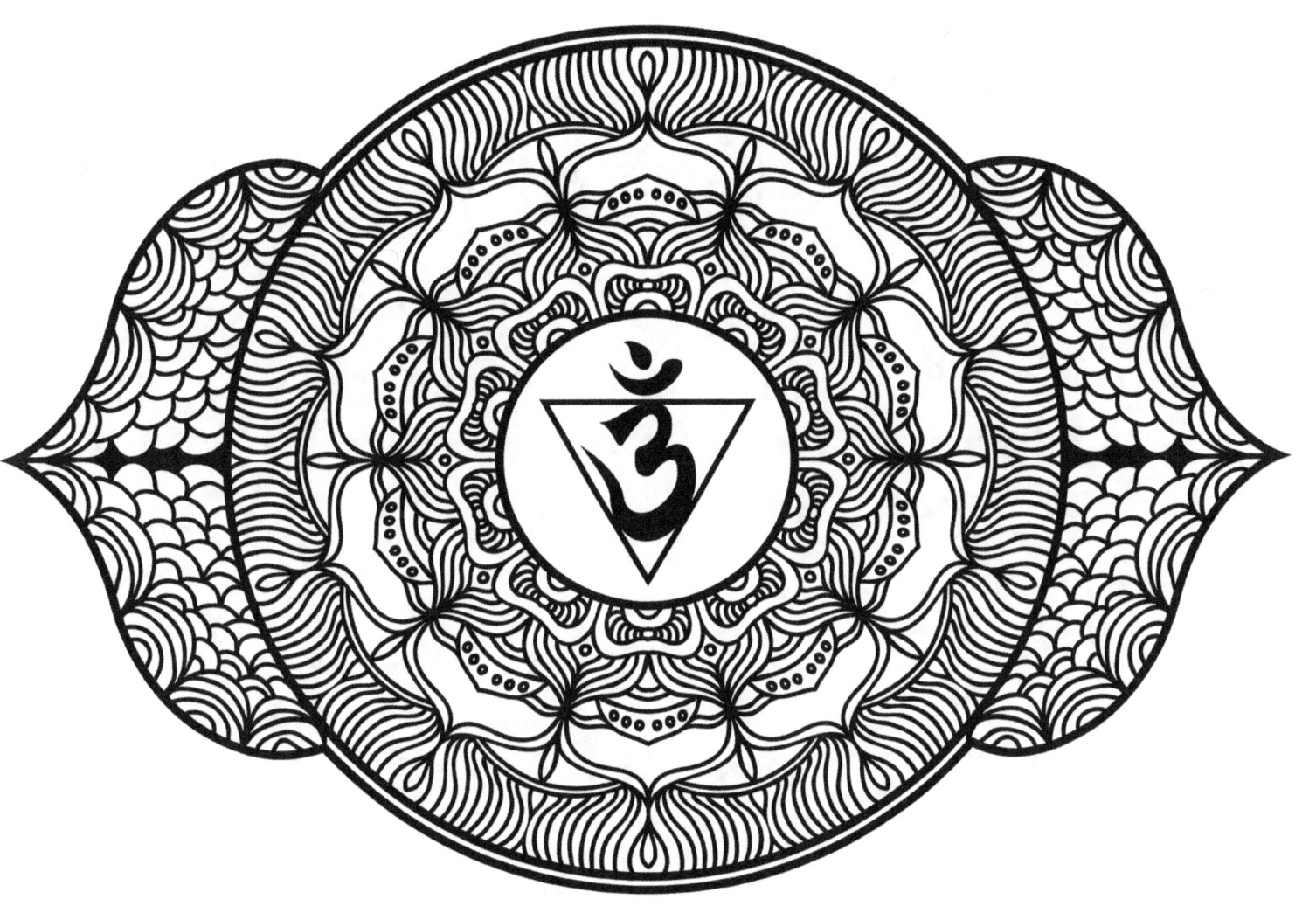

Throat Chakra Mandala

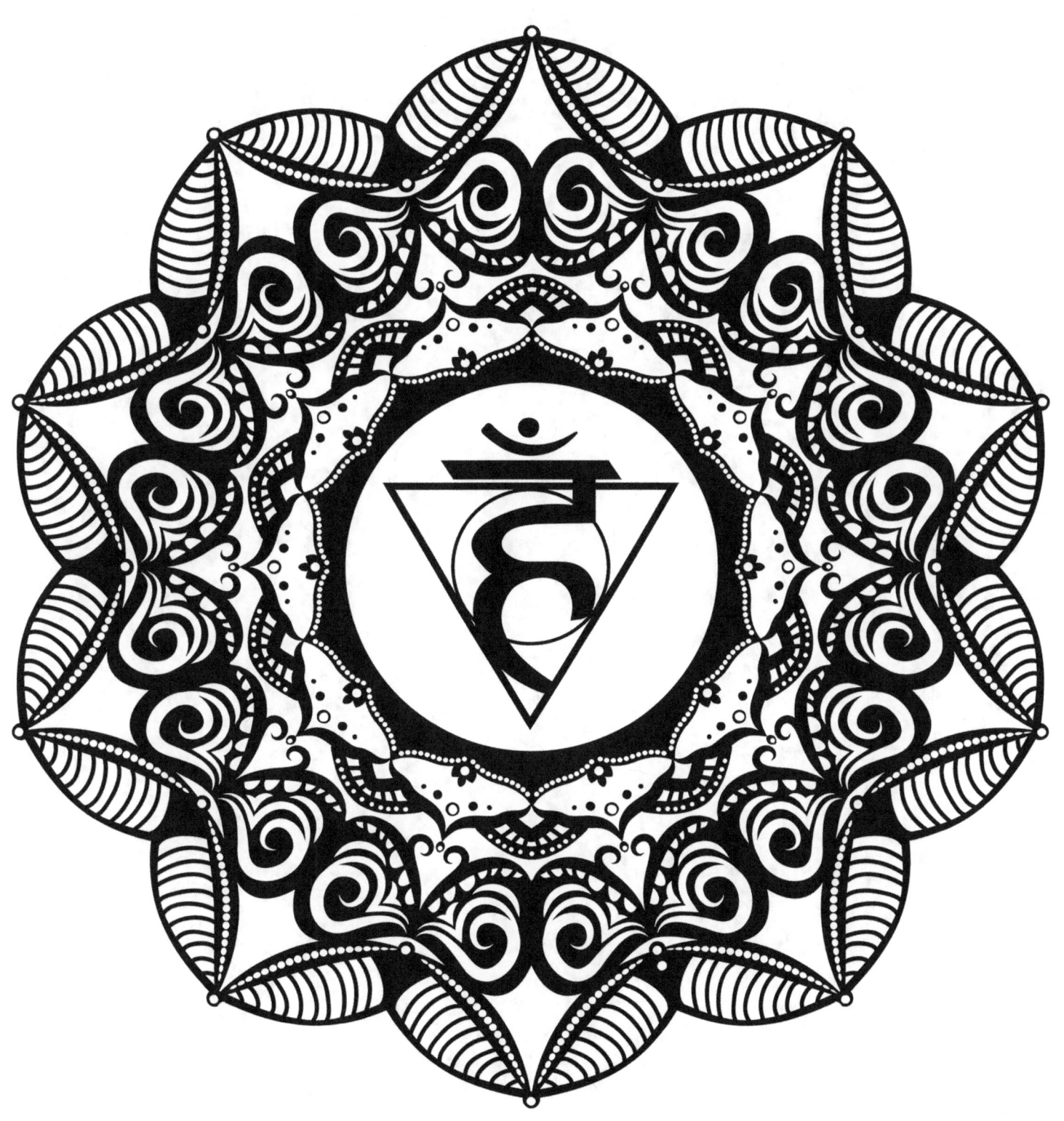

Heart Chakra Mandala

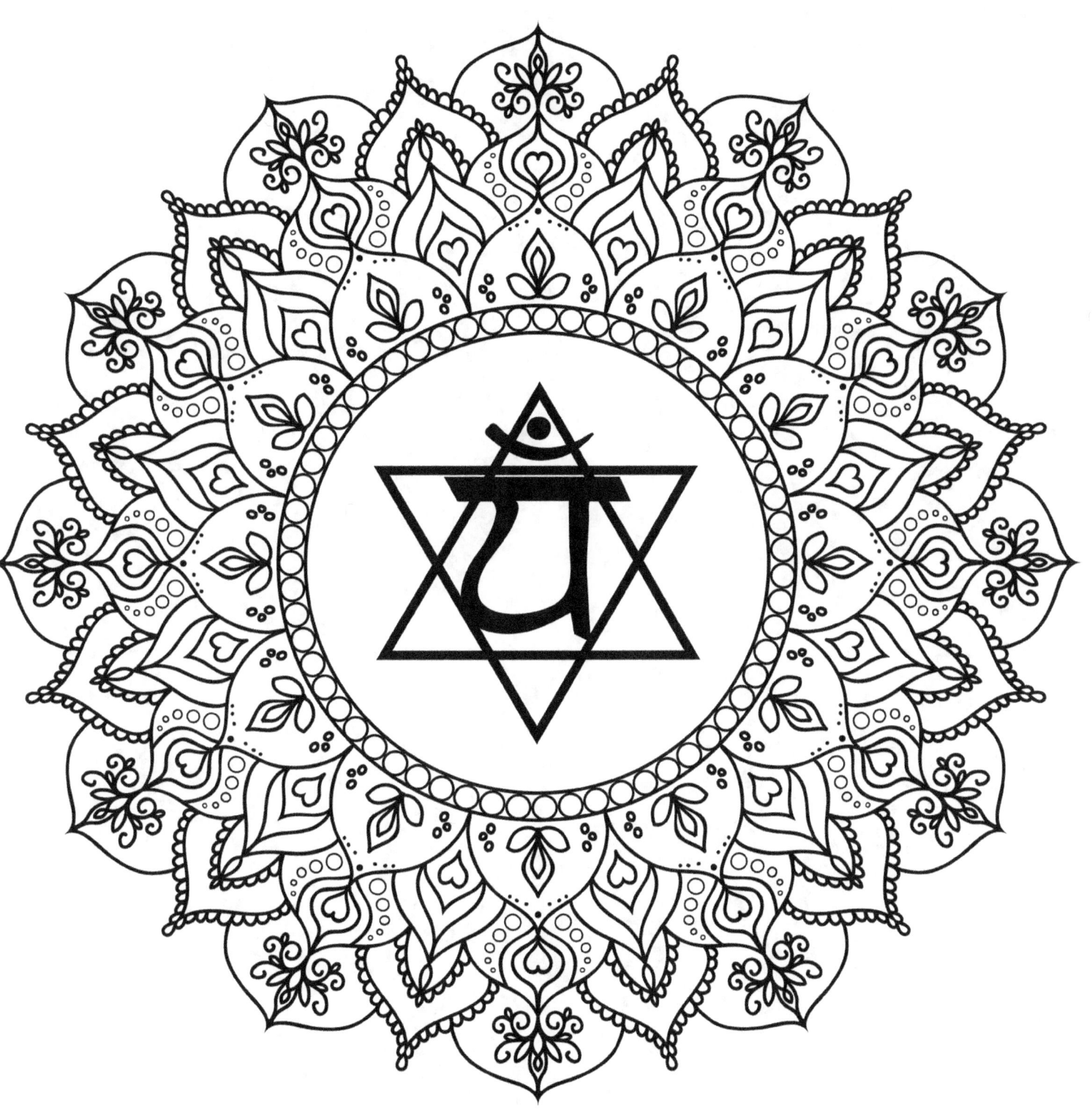

Solar Plexus Chakra Mandala

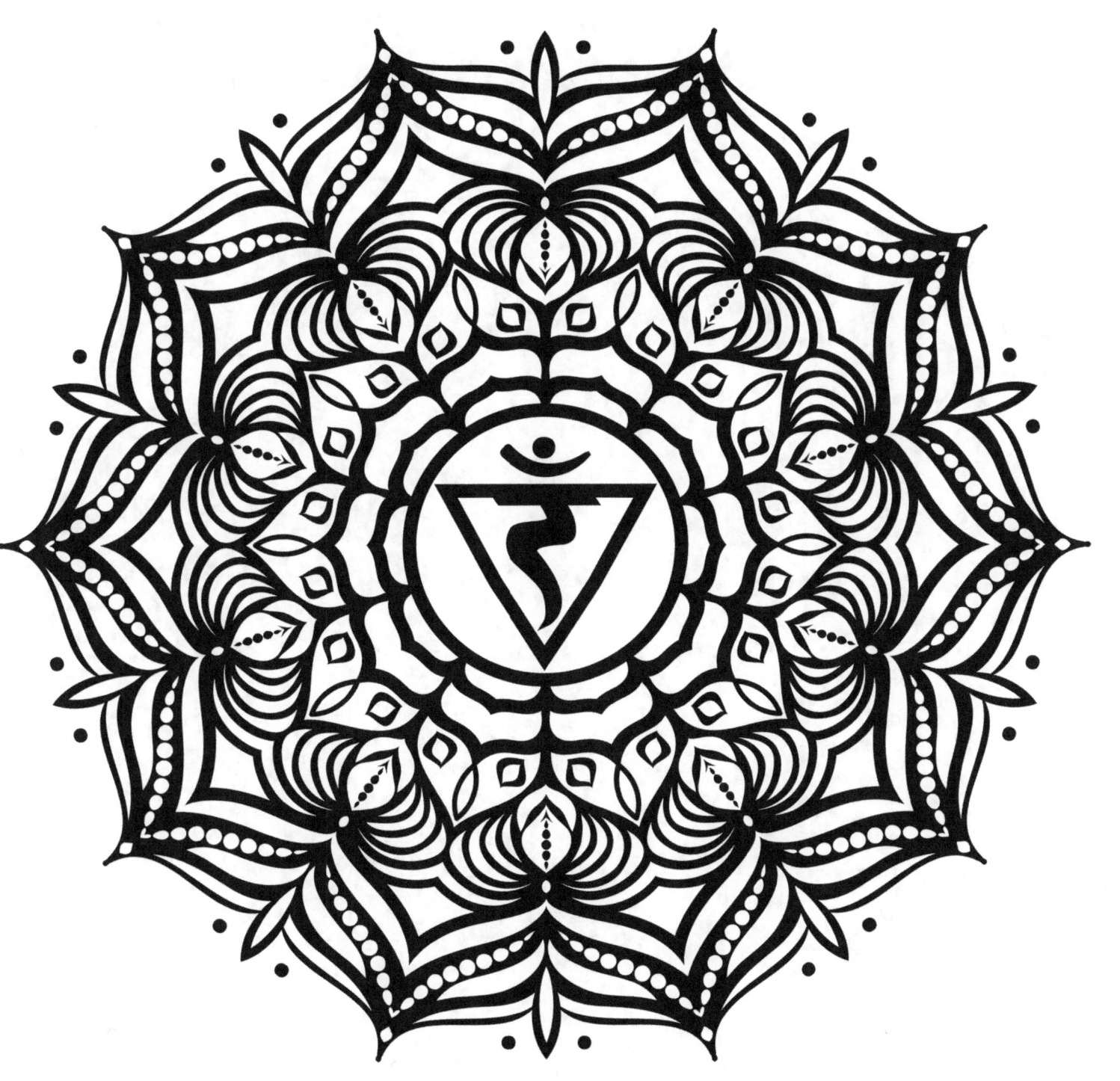

Sacral Chakra Mandala

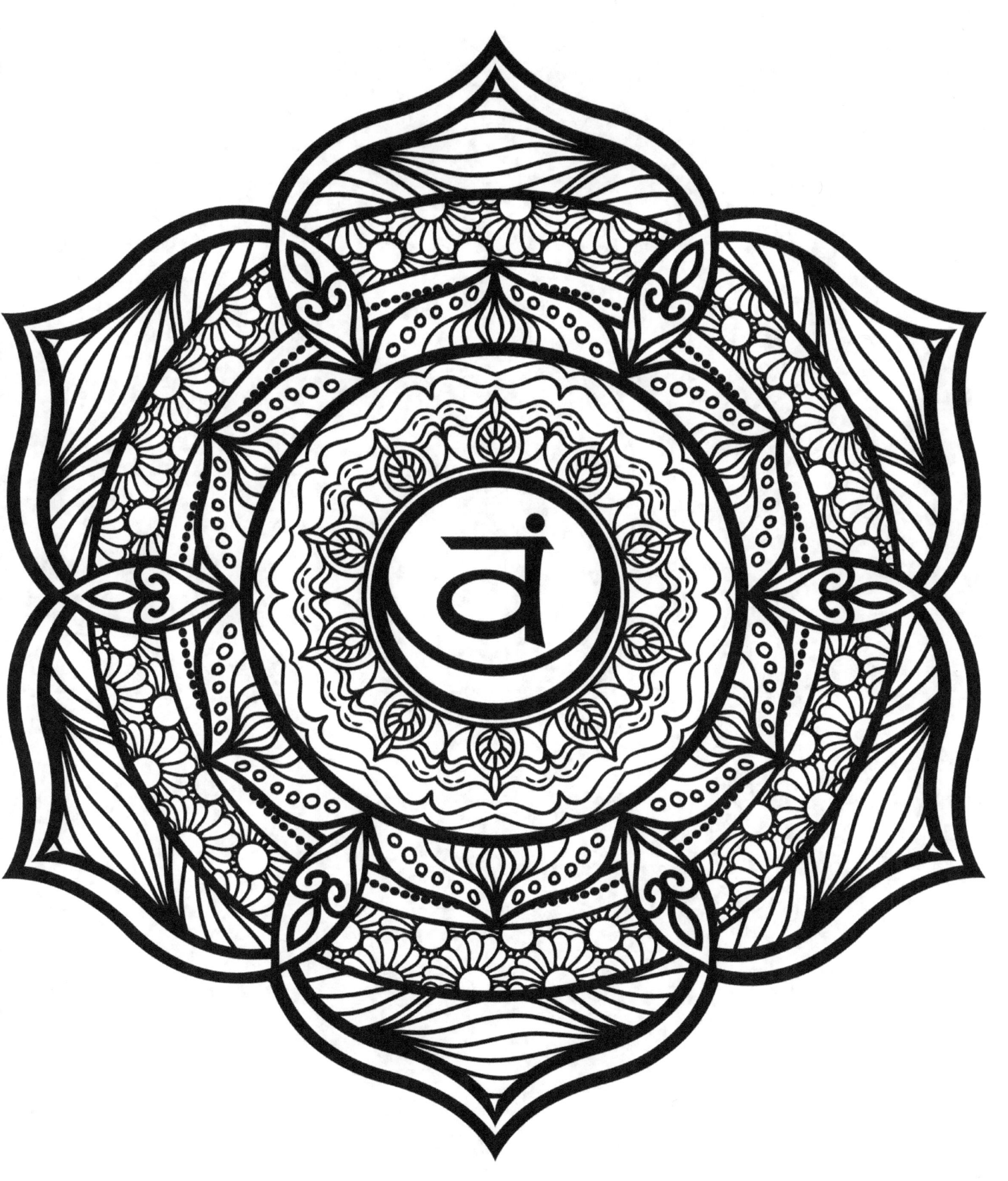

Root Chakra Mandala

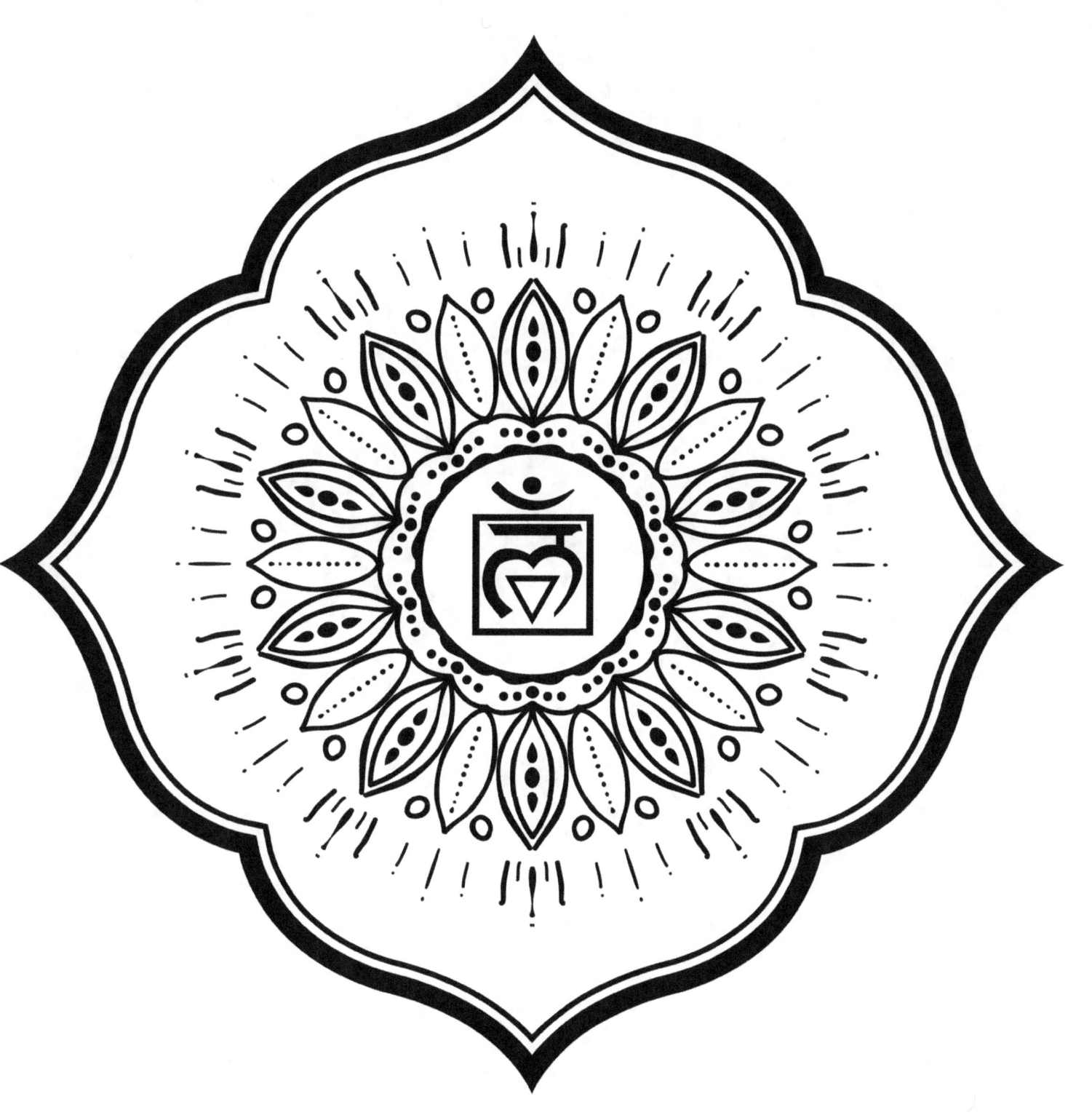

Sun Mandala

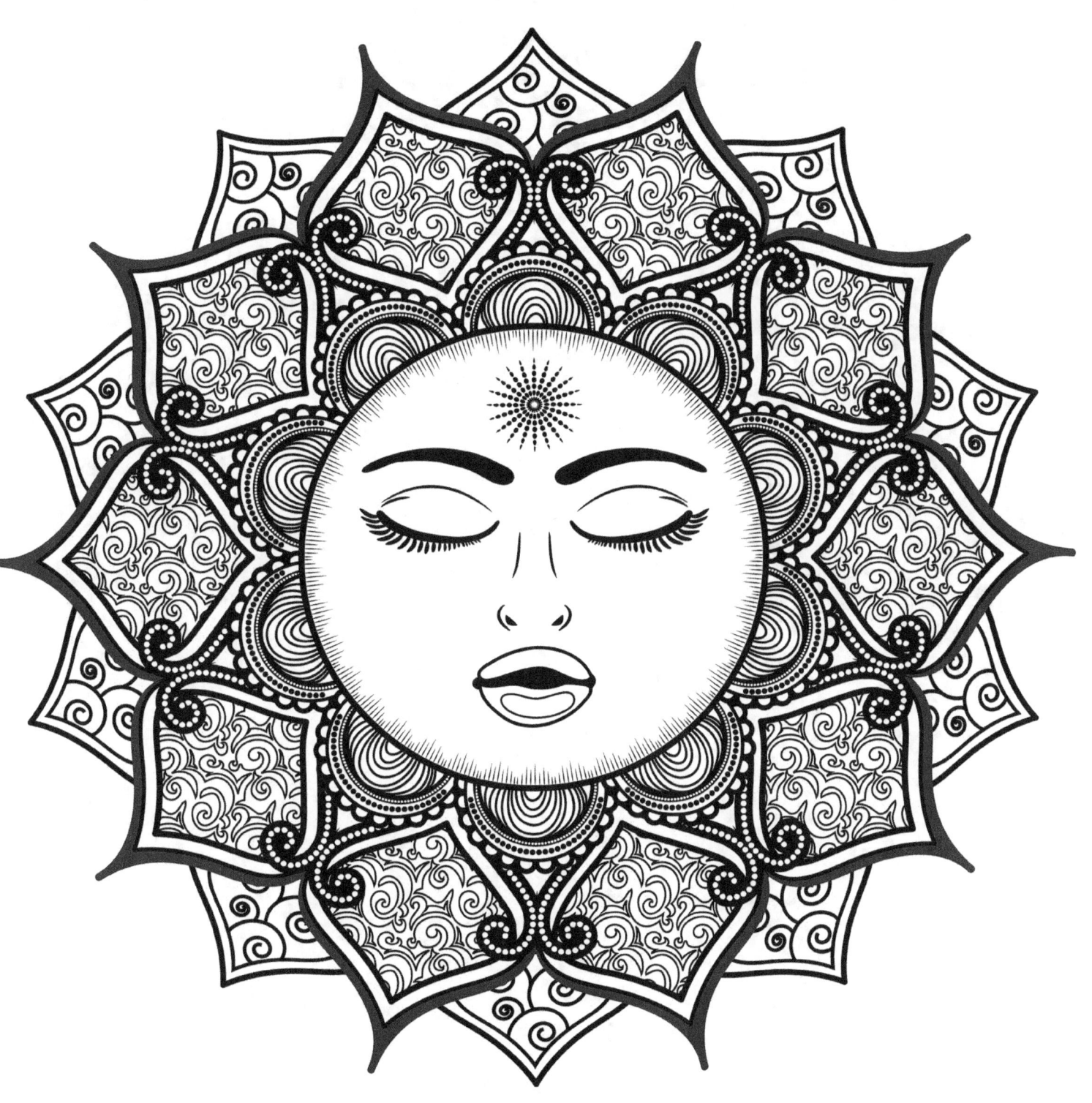

Crescent Moon Goddess Mandala

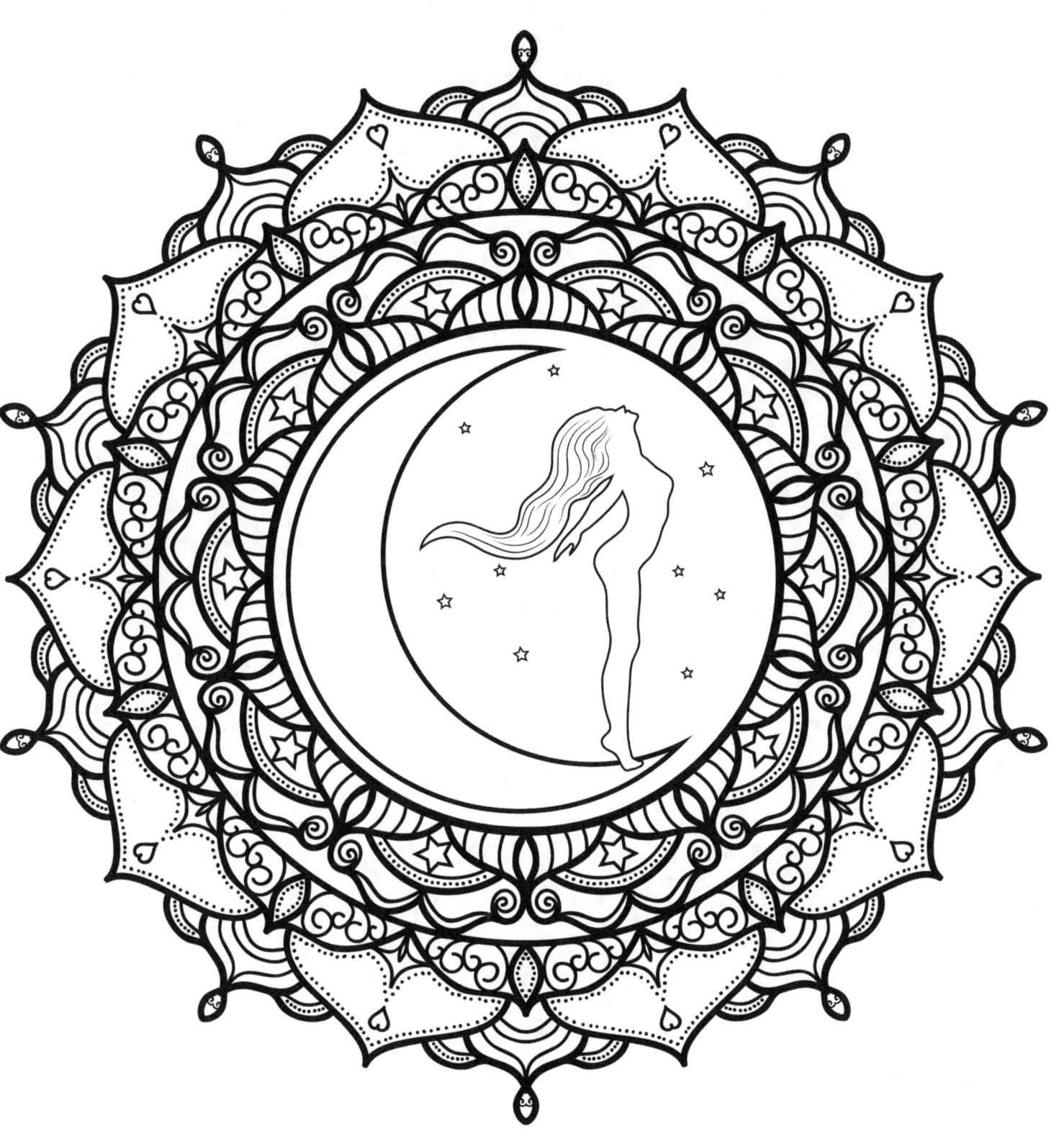

Flower Of Life Mandala

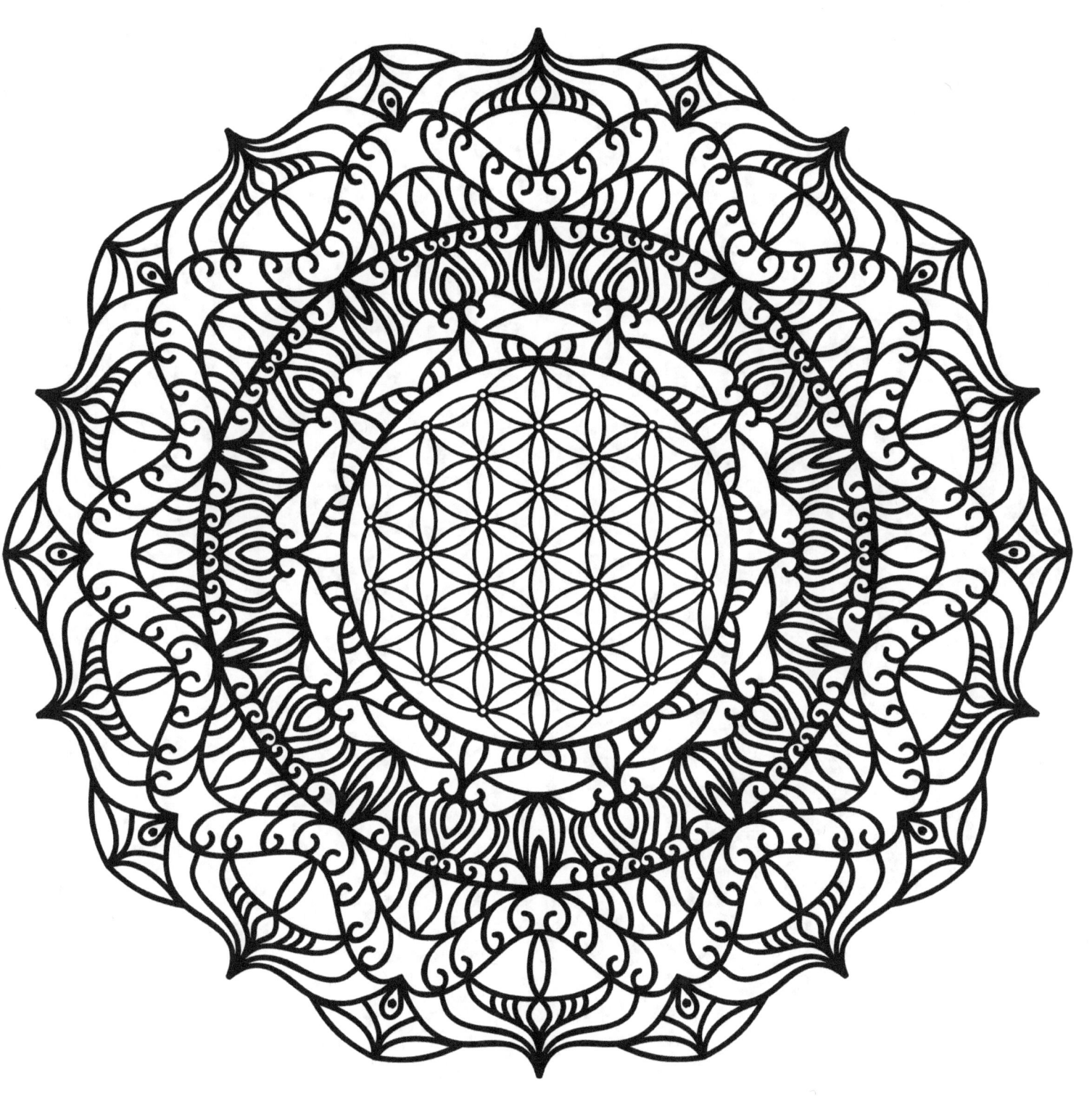

Henna Flower Mandala

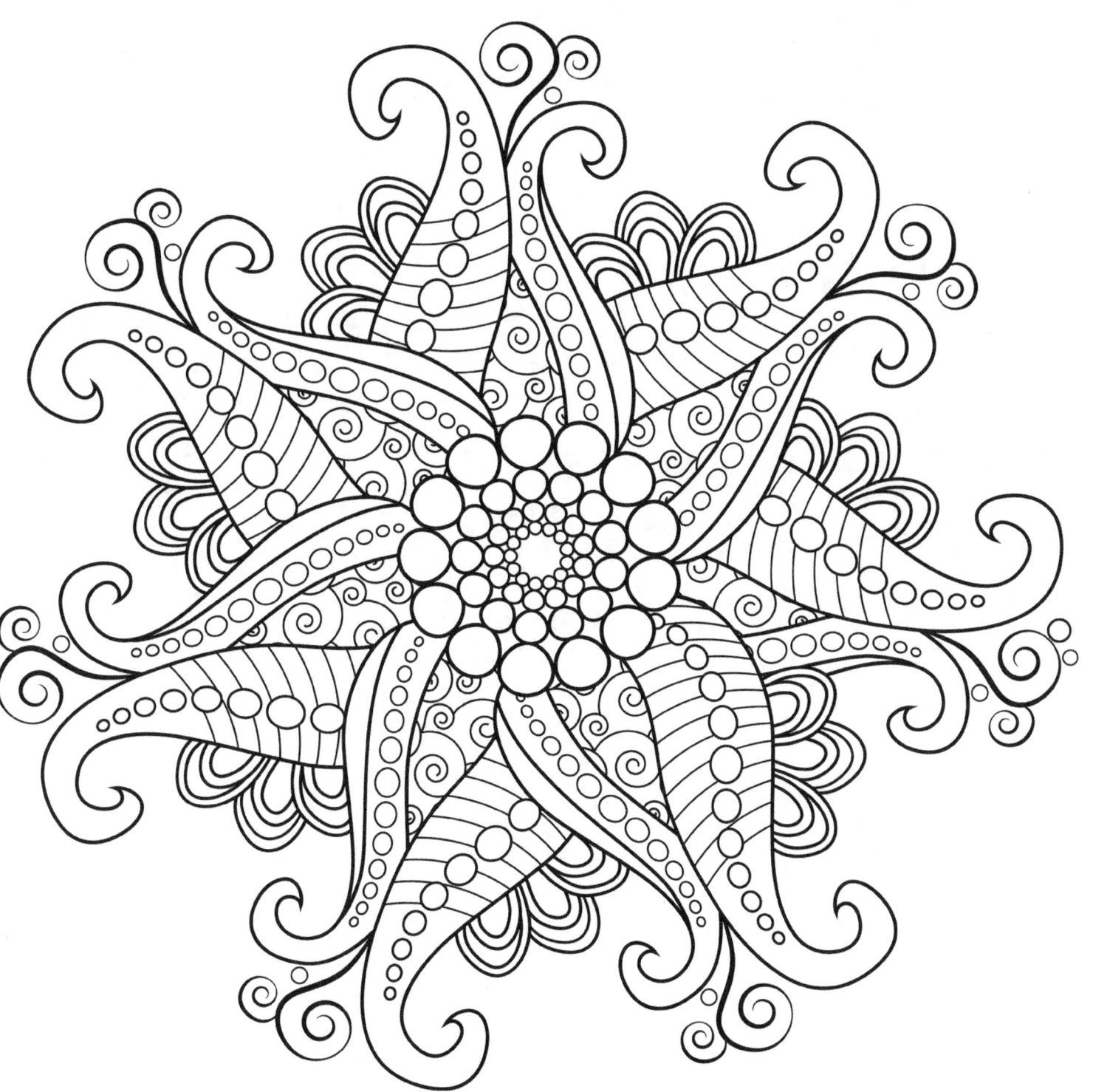

Flower Moon Mandala

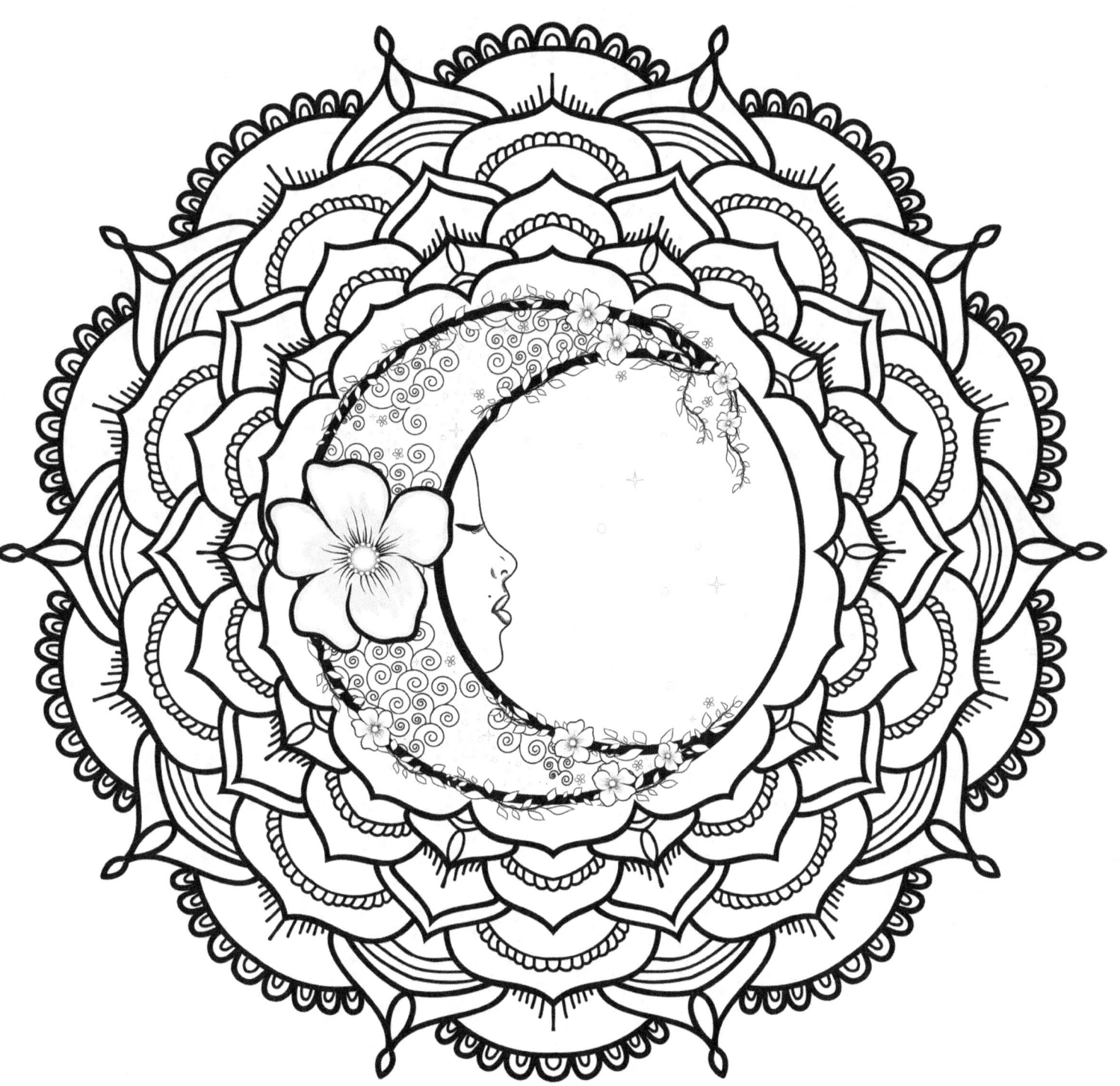

Tree Of Life Mandala

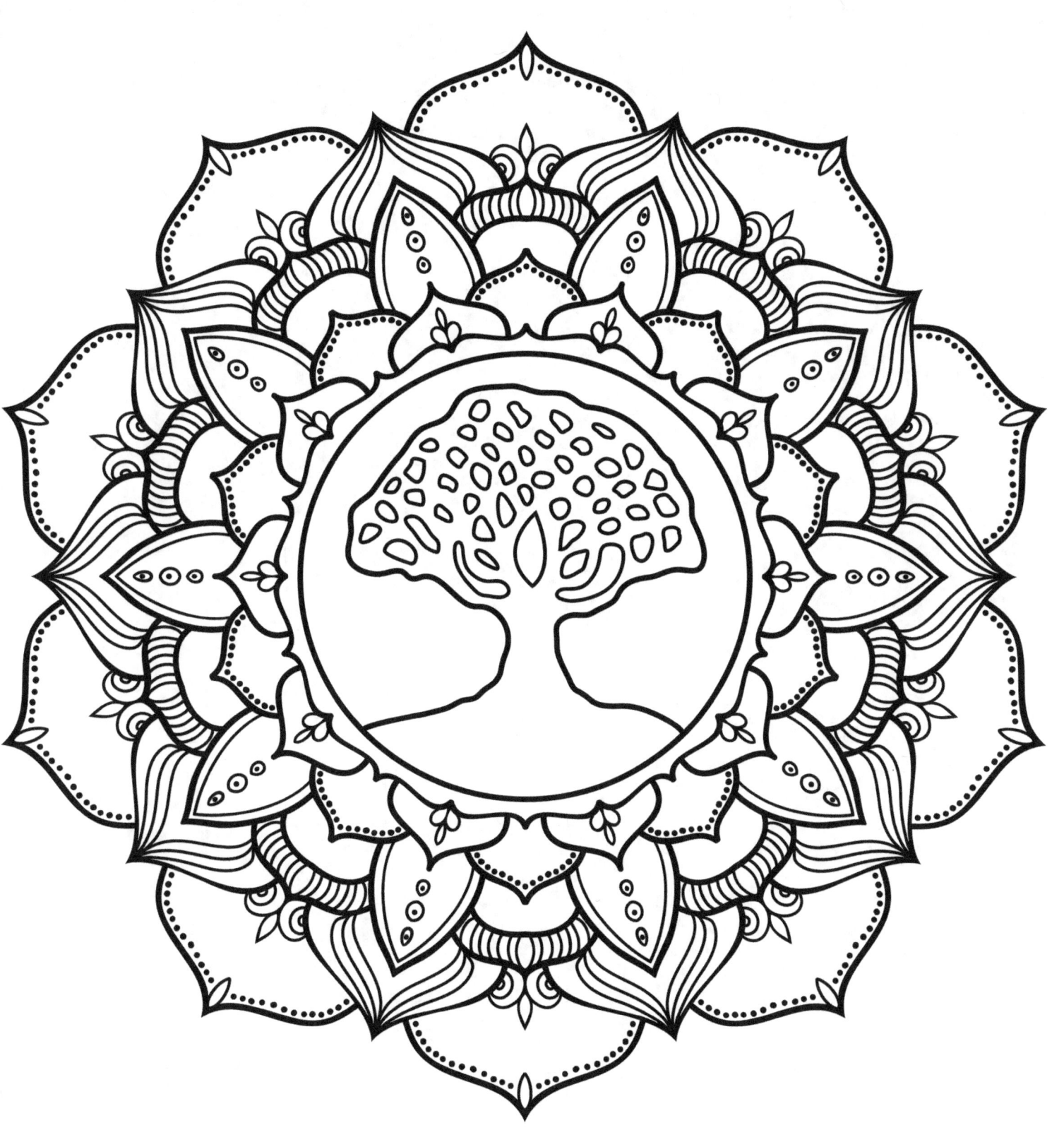

Flower Mandala

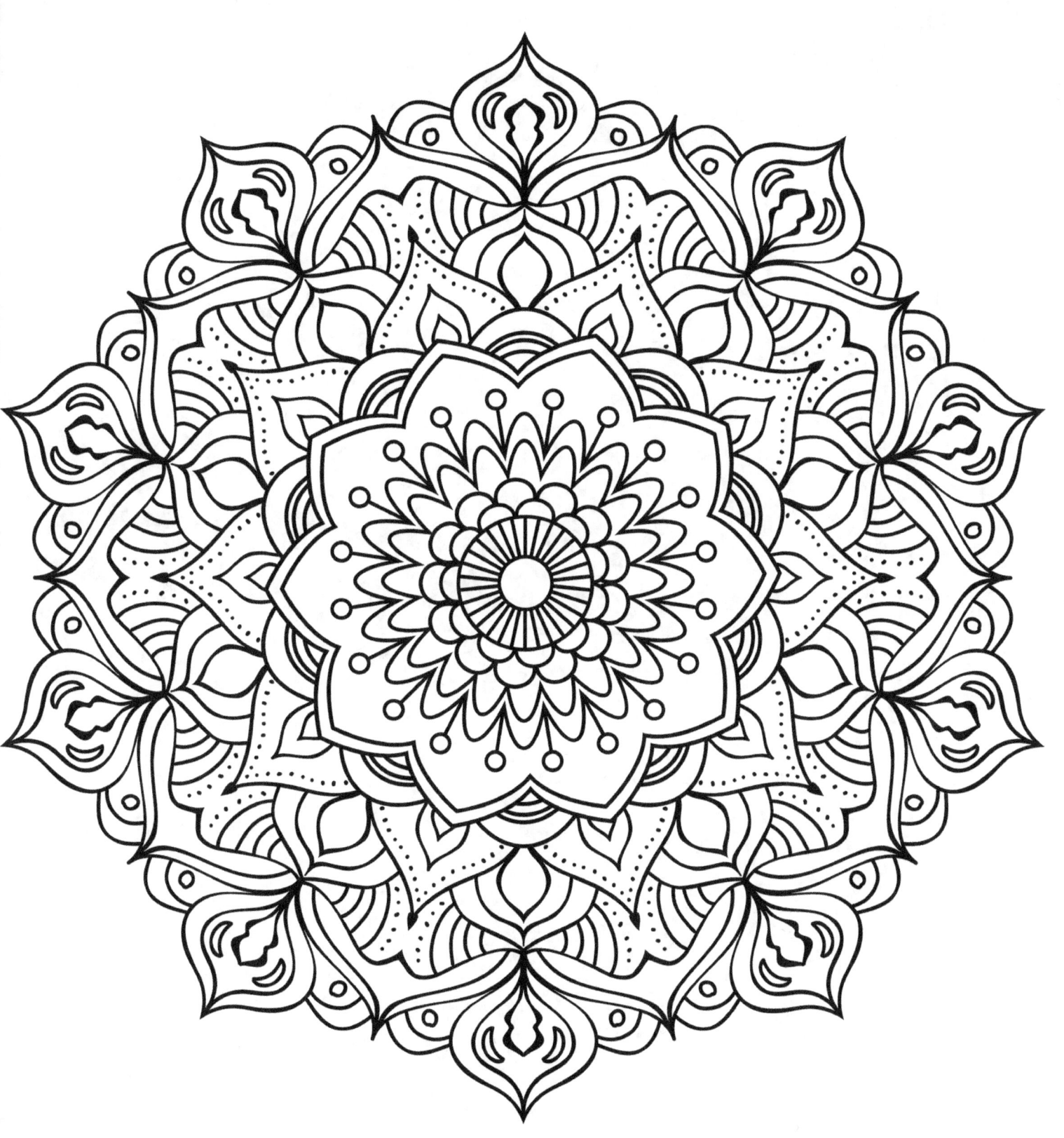

Circles Mandala

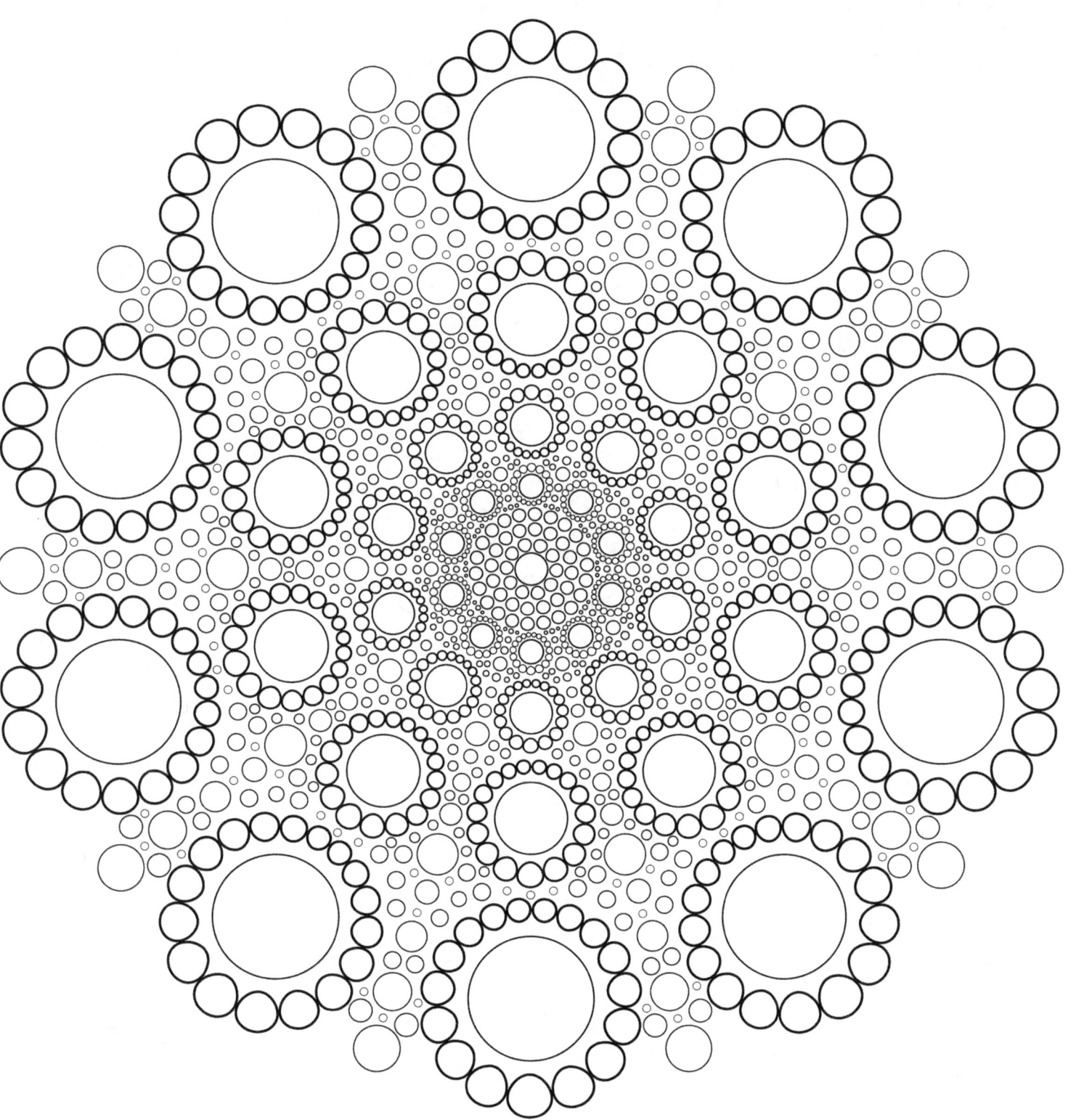

Star Mandala

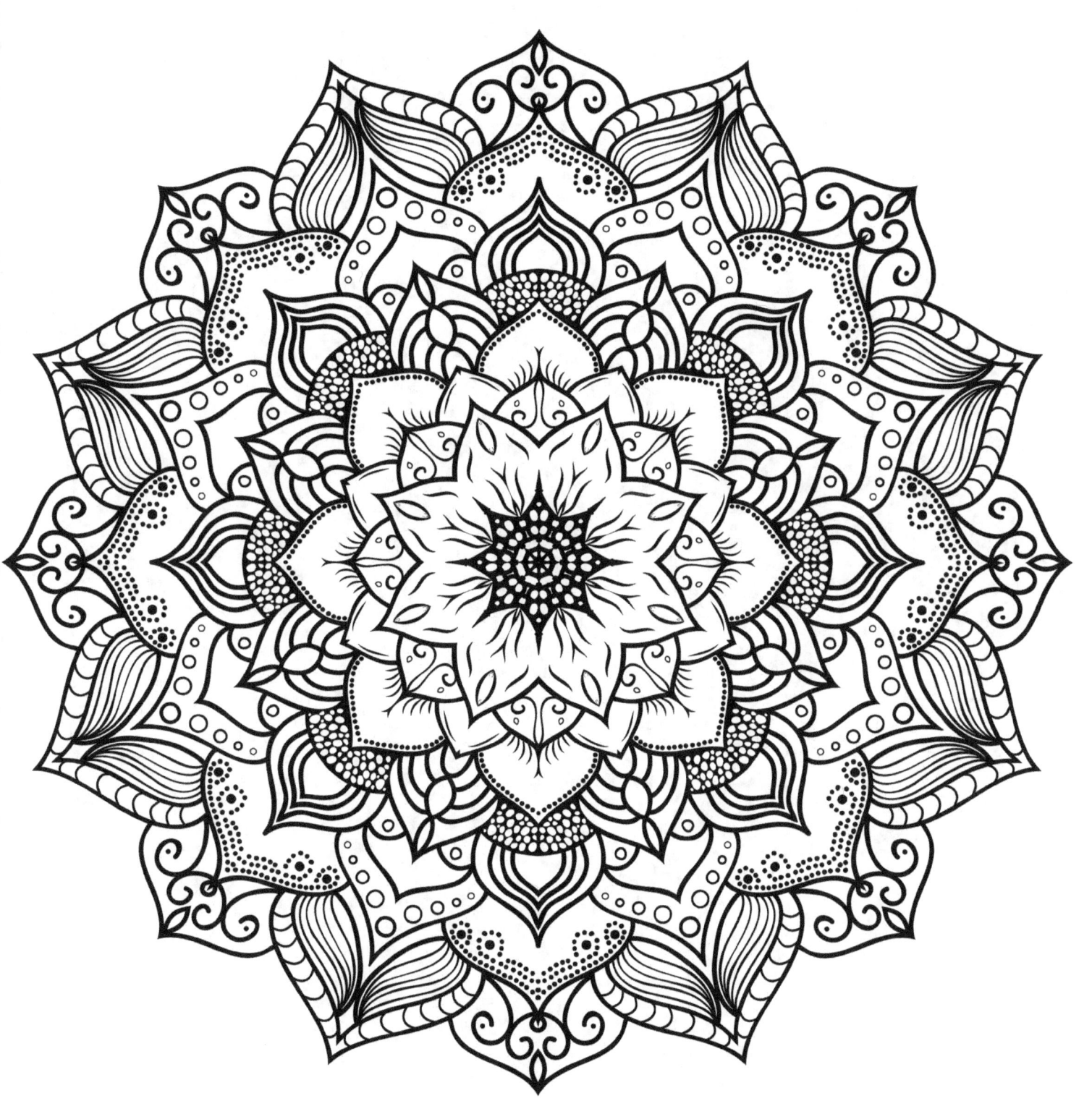

Spider Web Mandala

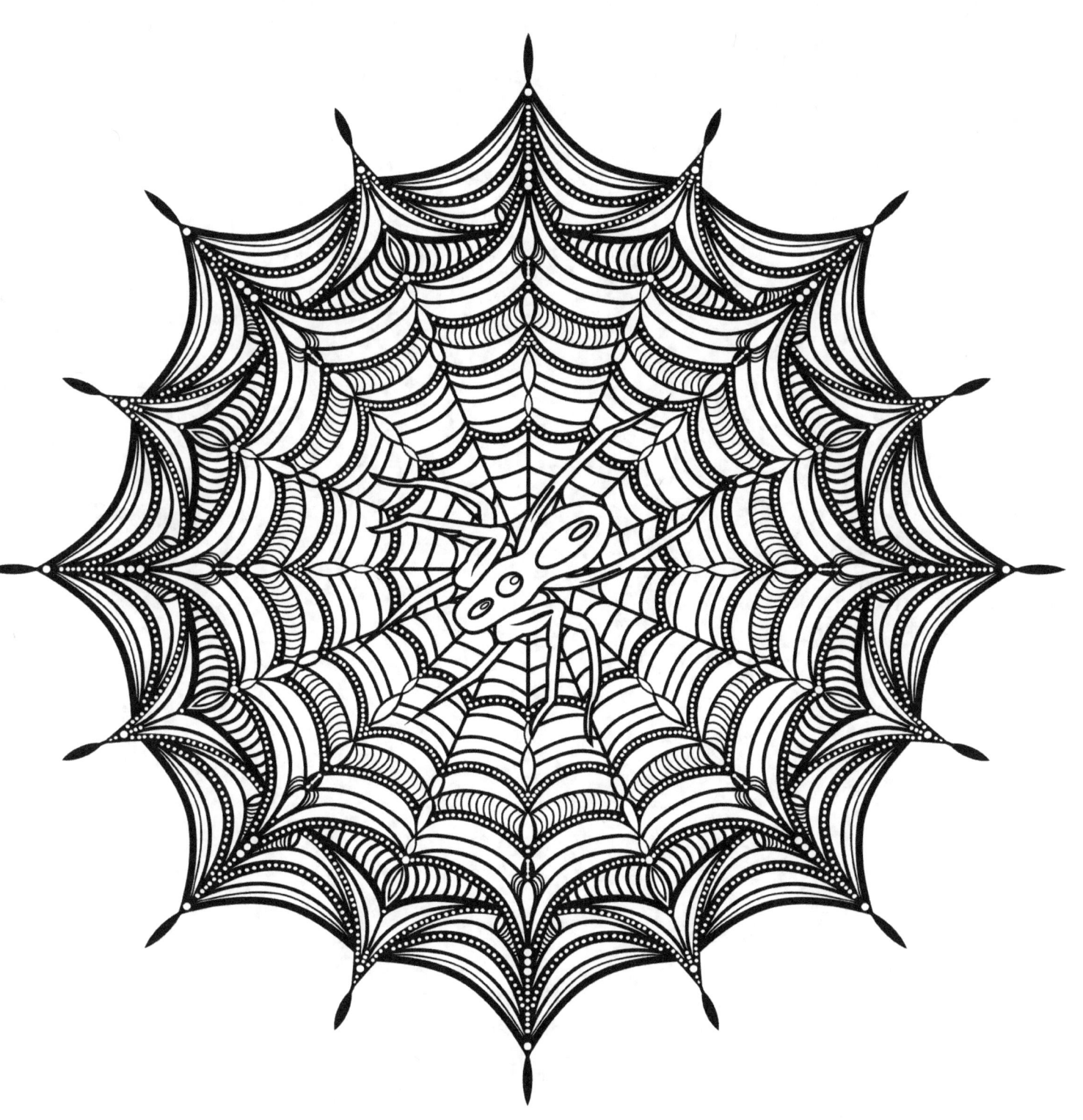

Ornate Flower Mandala

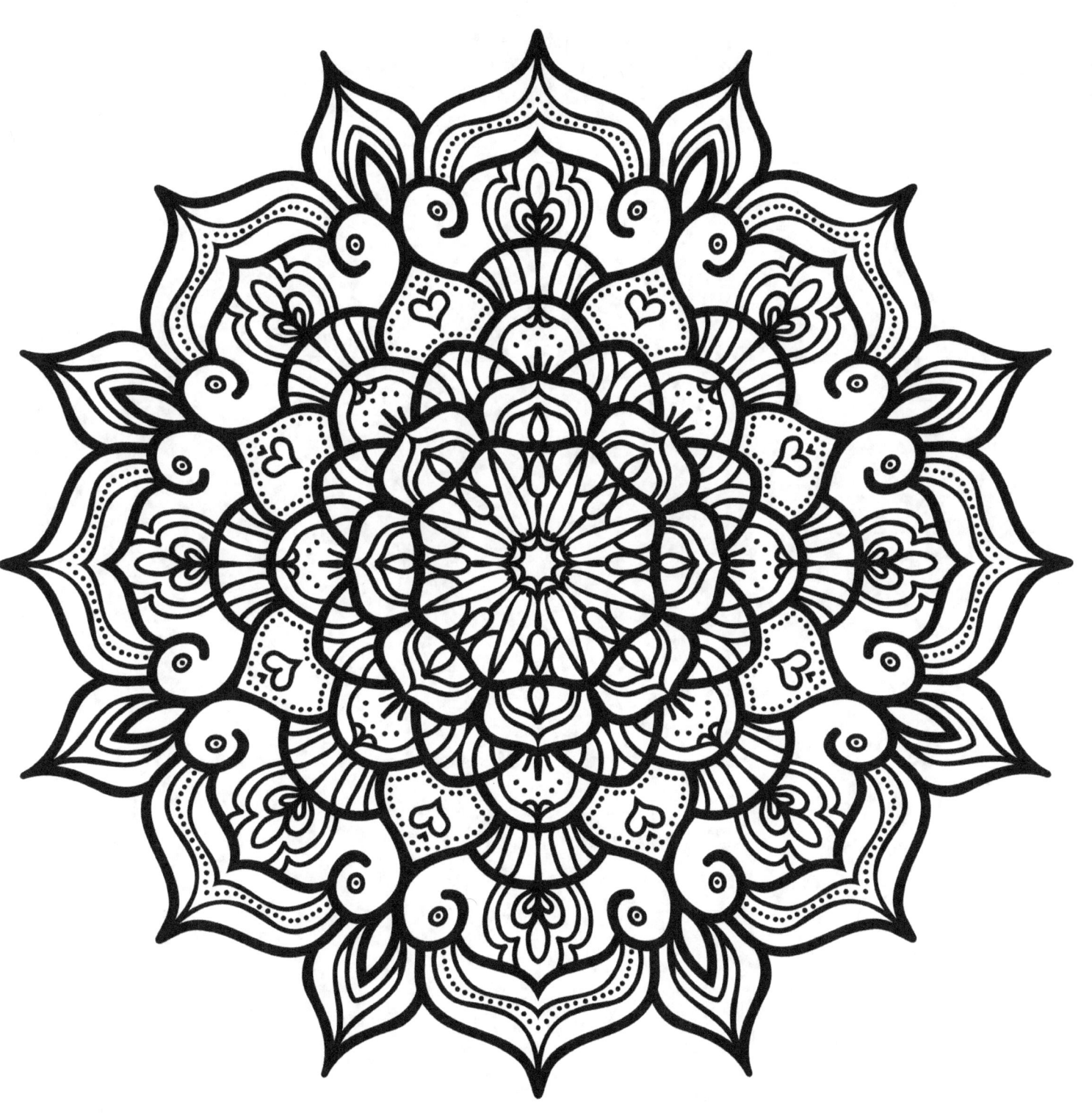

Flower Mandala

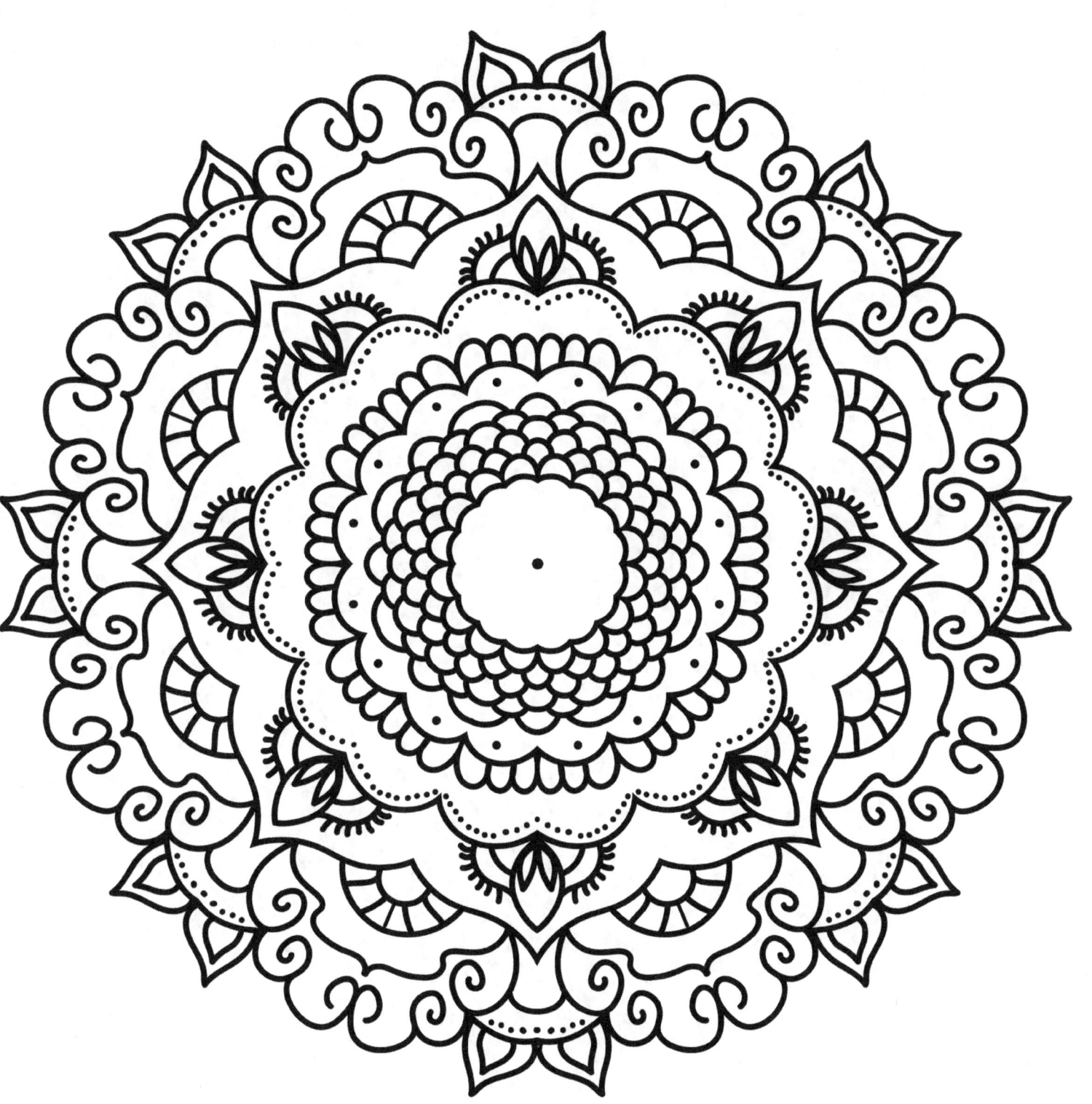

Swirl Dots Mandala

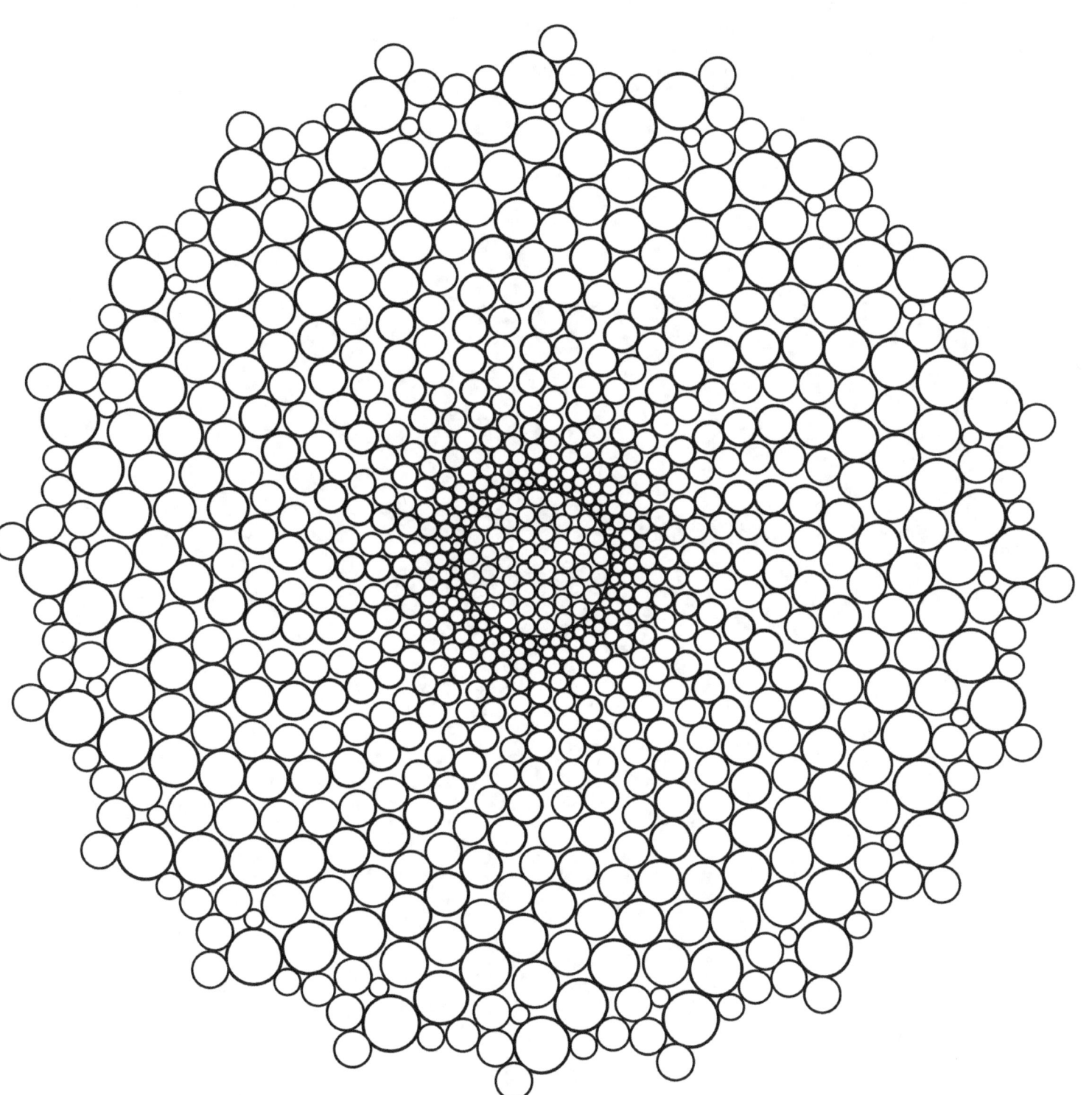

Sunflower Mandala

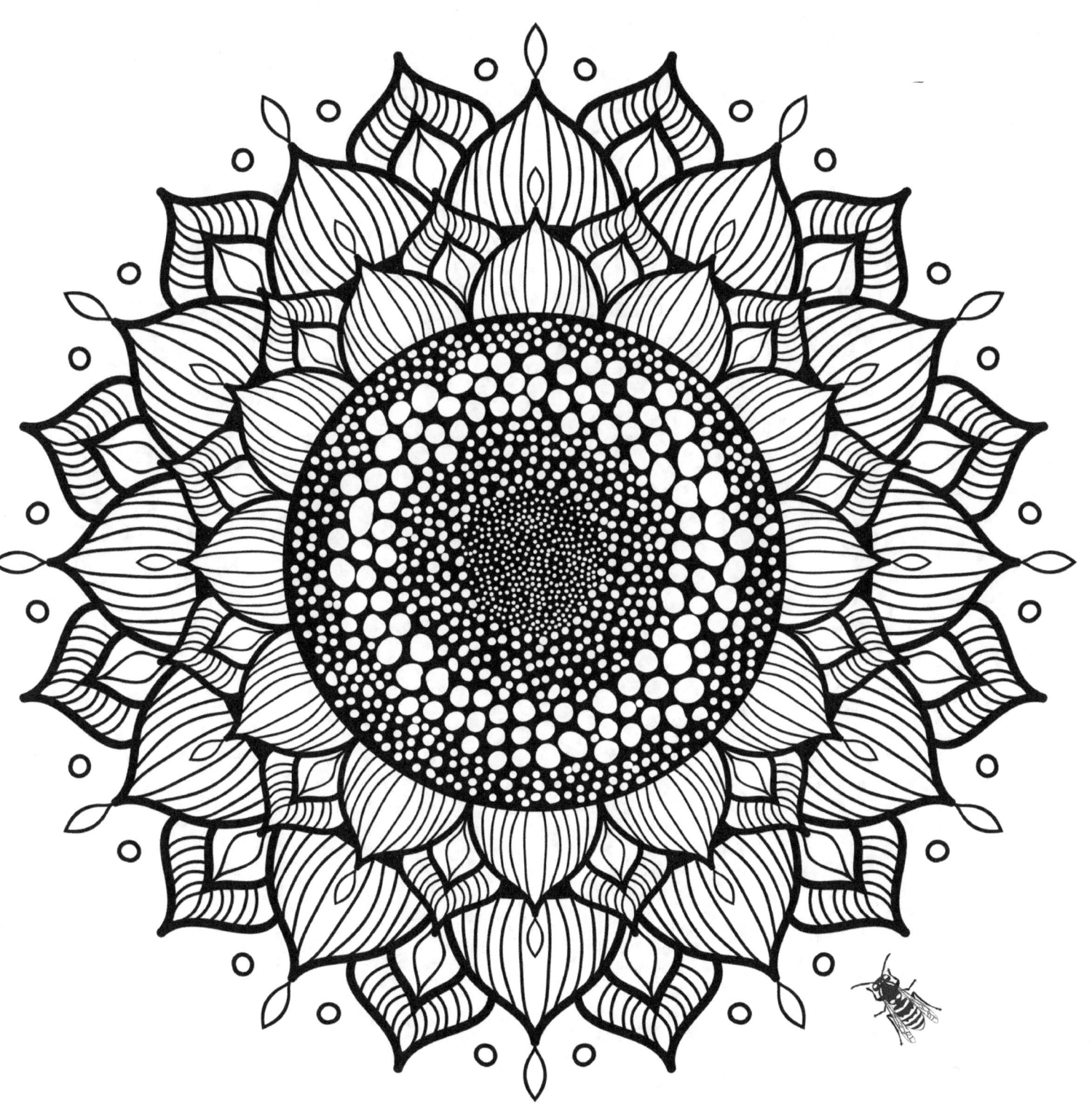

Lotus Seven Chakra Mandala

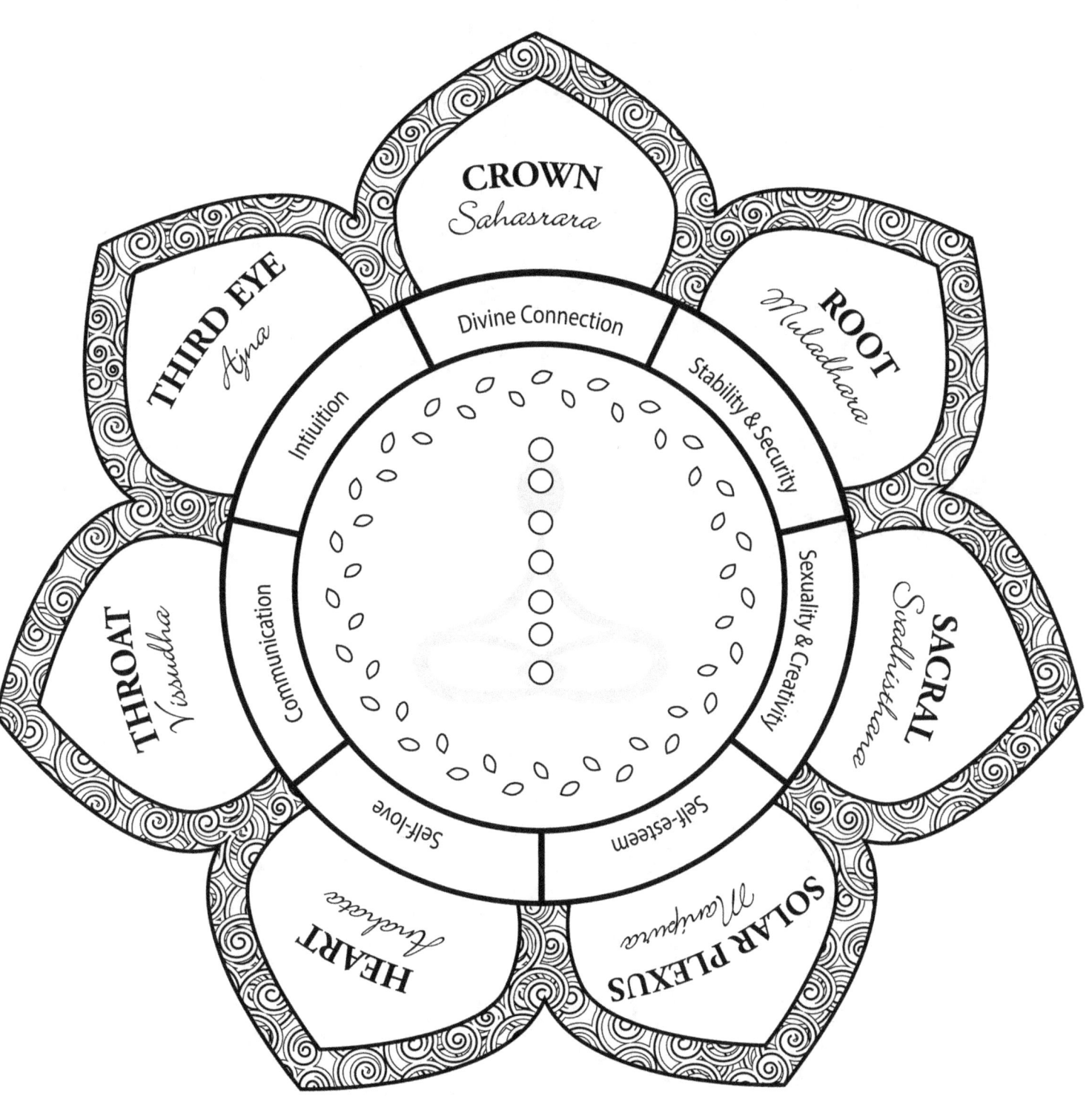

Third Eye Chakra Face Mandala

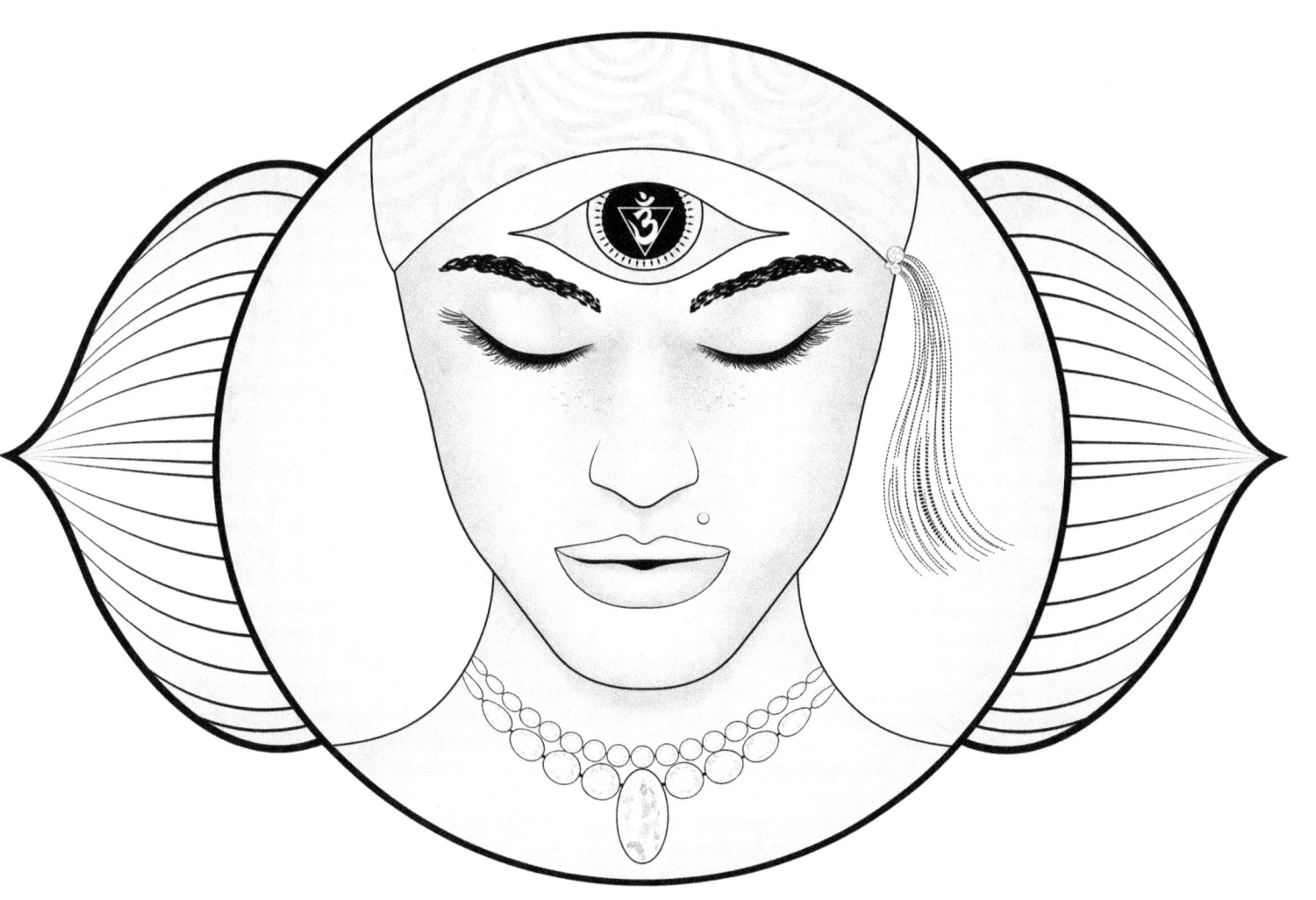

Heart Chakra Illustration Mandala

The heart chakra color is green and represents love, self-love, relationships, empathy, compassion, forgiveness, acceptance, transformation, change, and center of awareness. The symbol for the heart chakra (or Anahata) is a twelve-petaled lotus with a circle containing two intersecting triangles. The intersecting triangles, or six-pointed star, symbolize the air element and its all-encompassing attributes. Some of the animals associated with the heart chakra added into this design are the deer, which represents gentleness, sensitivity, and vulnerability. Another heart chakra animal is the hummingbird, which represents joy, happiness, love, and light. The hibiscus flower is also known to be associated with the heart chakra.

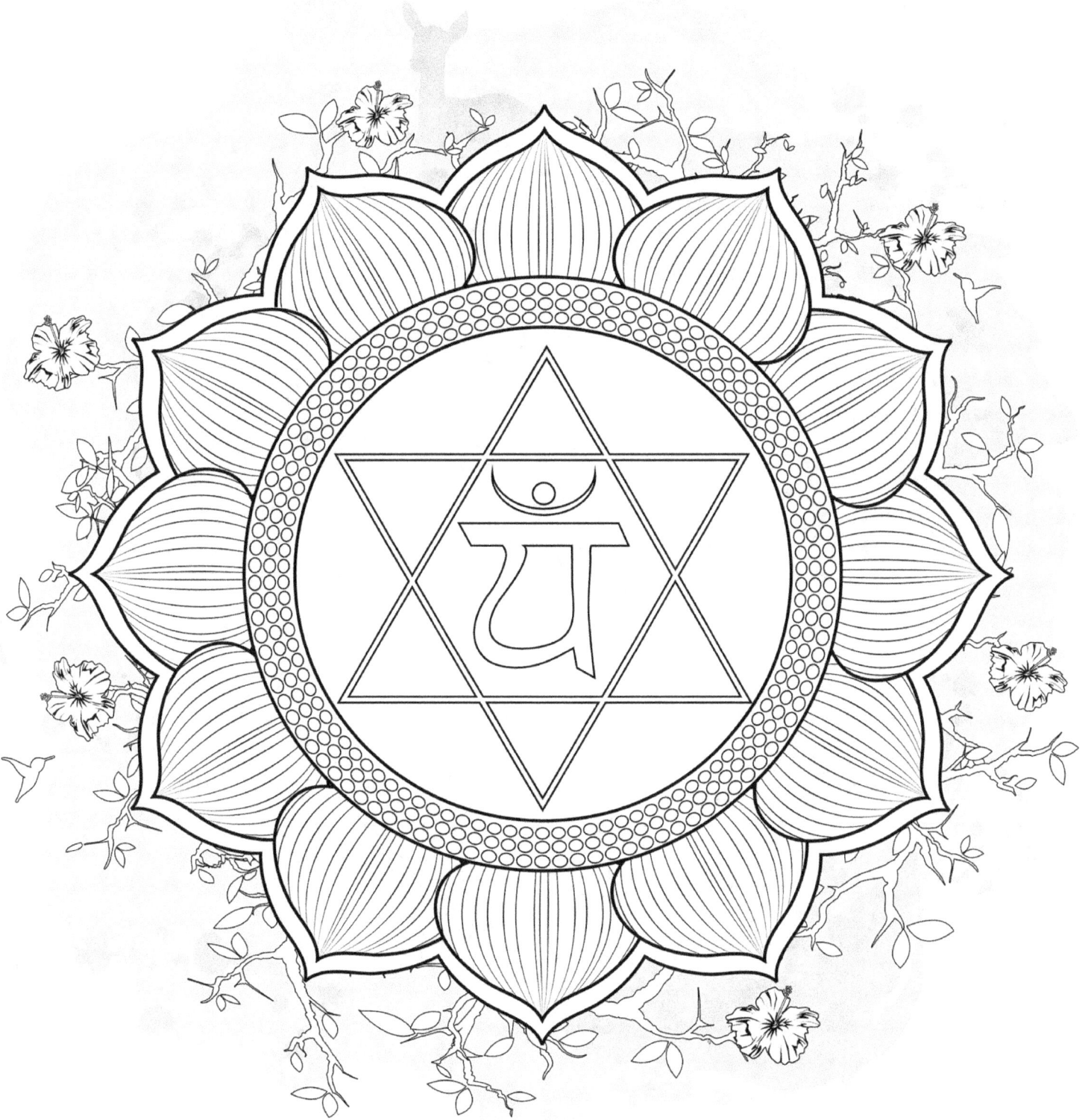

Crown Chakra Mandala

The crown (7th chakra) is located at the top of the head. It represents states of higher consciousness and divine connection. Imbalanced attributes would be cynicism, disregarding what is sacred, closed mindedness, and disconnection with spirit.

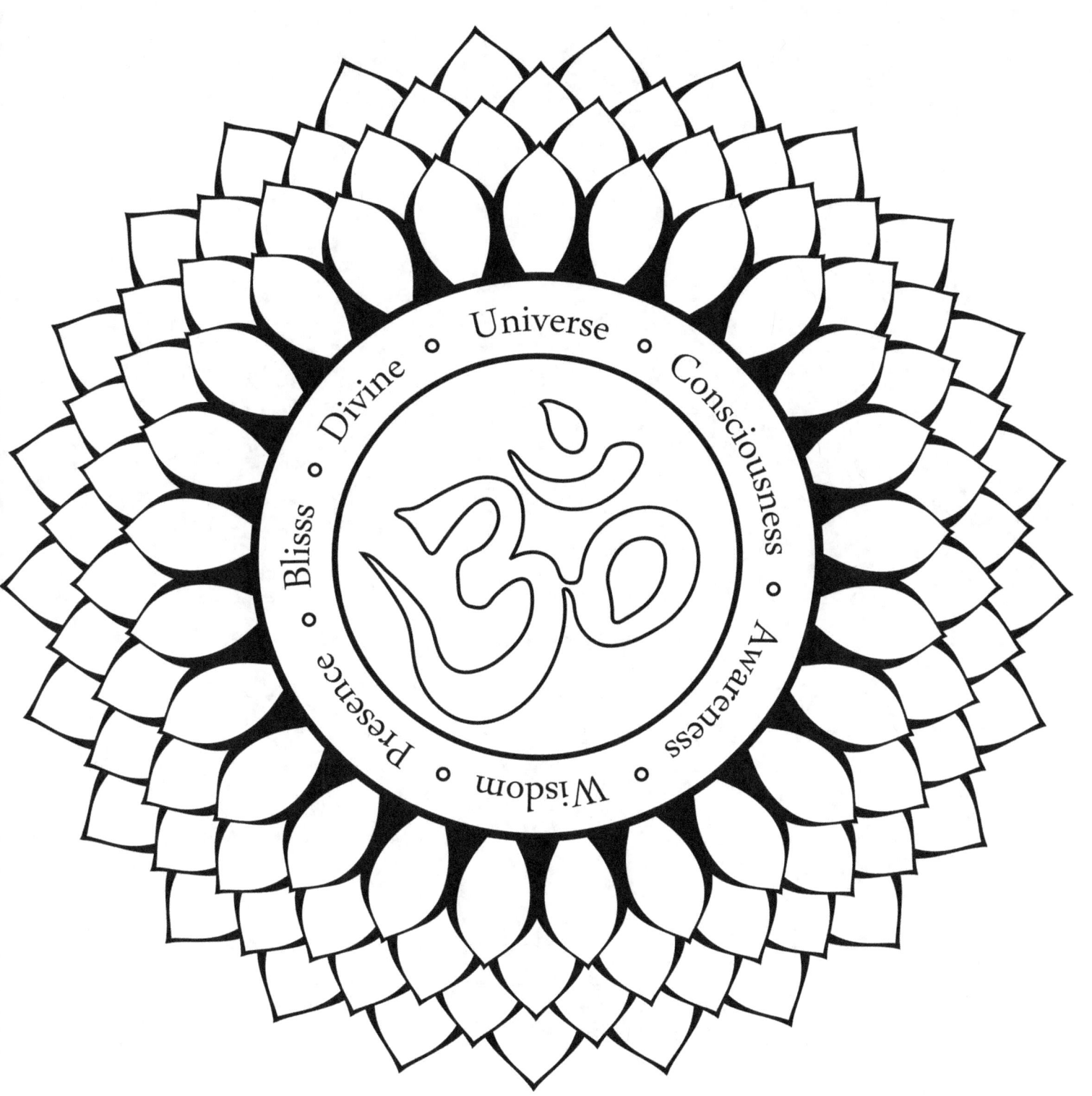

Third Eye Chakra Mandala

The third eye (6th chakra) is located in the center of the forehead, between the eyebrows. It represents intuition, foresight, and is driven by openness and imagination. Imbalanced attributes would be lack of direction and lack of clarity.

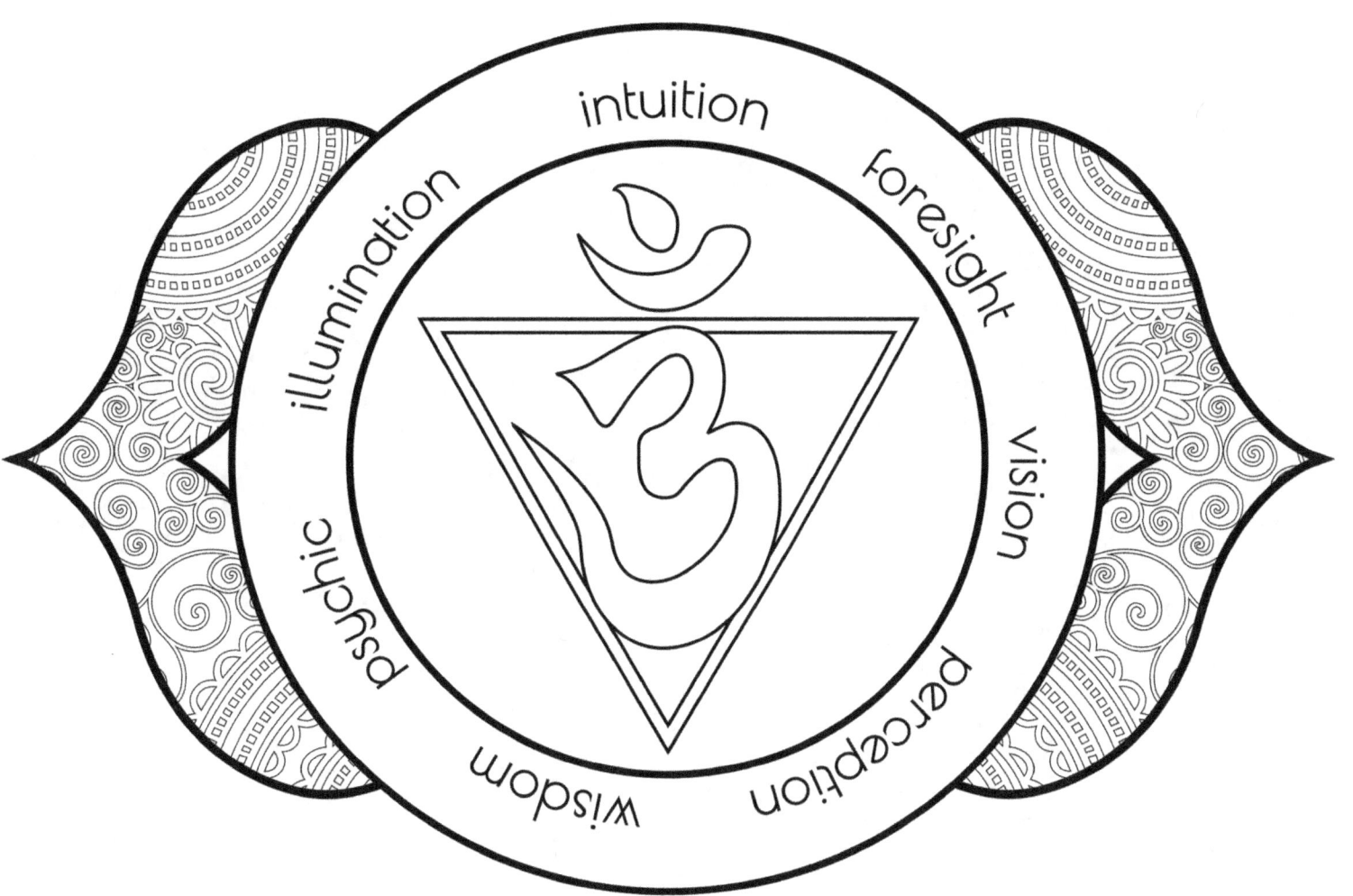

Throat Chakra Mandala

The throat (5th chakra) is located at the center of the neck. It represents the ability to speak and communicate clearly and effectively. Imbalanced attributes would be shyness, being withdrawn, arrogance, and increased anxiety.

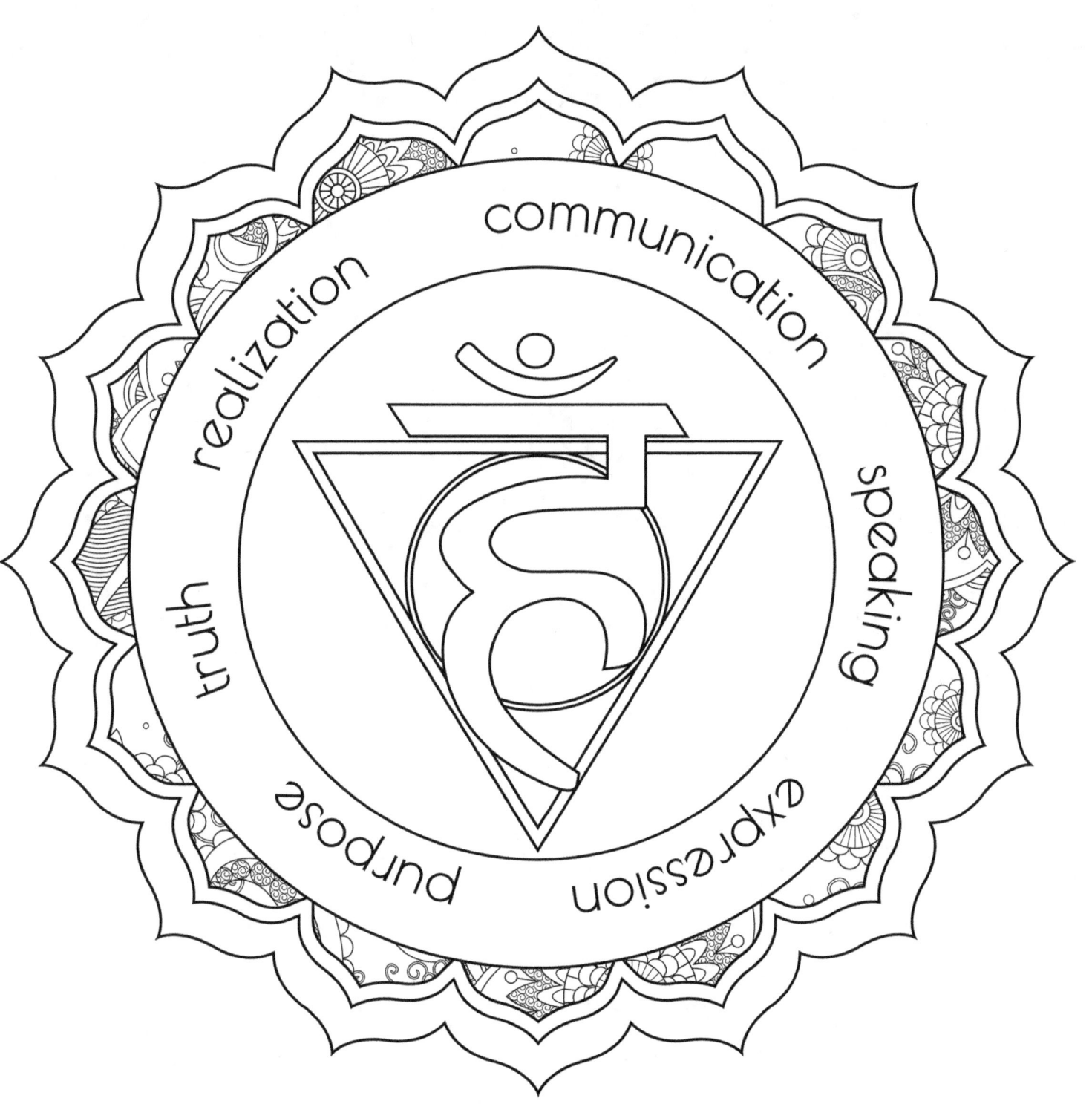

Heart Chakra Mandala

The heart (4th chakra) is located in the center of the chest. It represents love, self-love, and governs our relationships. Imbalanced attributes would be depression, difficulty in relationships, and lack of self-discipline.

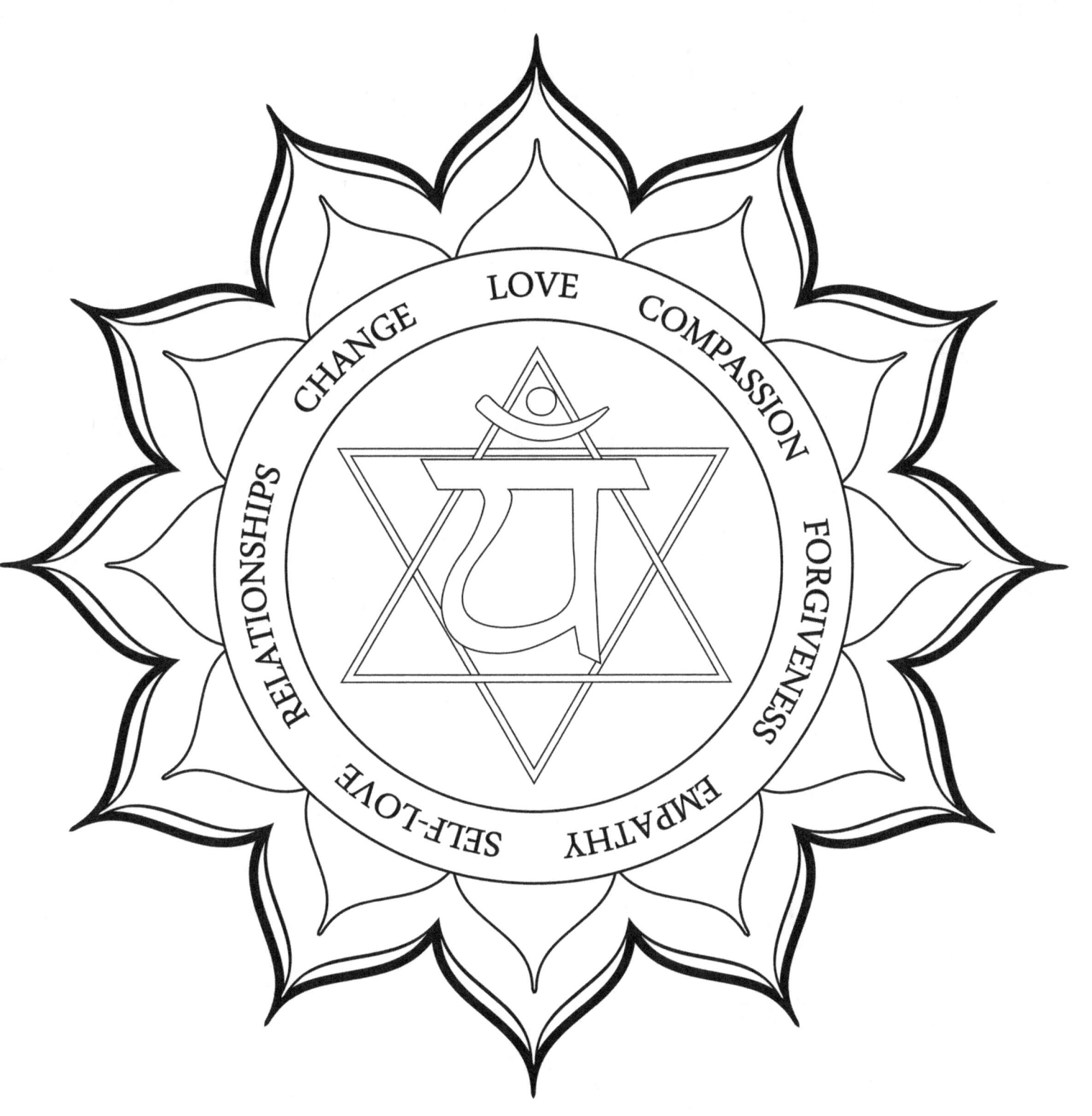

Solar Plexus Chakra Mandala

The solar plexus (3rd chakra) is located below the chest. It represents self-esteem, pleasure, will-power, and personal responsibility. Imbalanced attributes would be low self-esteem, control issues, manipulative tendencies, and misuse of power.

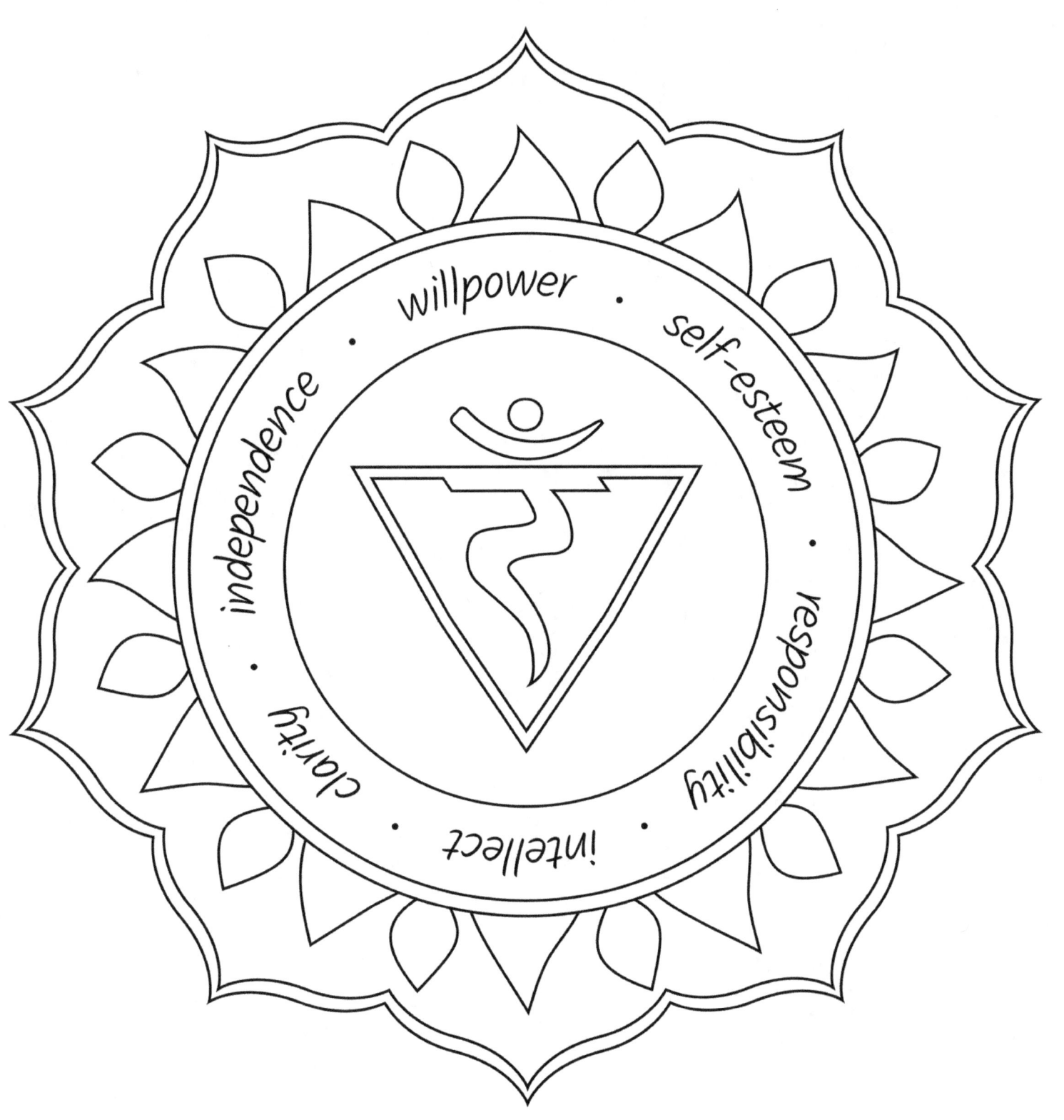

Sacral Chakra Mandala

The sacral (2nd chakra) is located below the navel. It represents creative and sexual energies. Imbalanced attributes would be lack of or repressed creativity, sexual dysfunction, withheld intimacy, and emotional isolation.

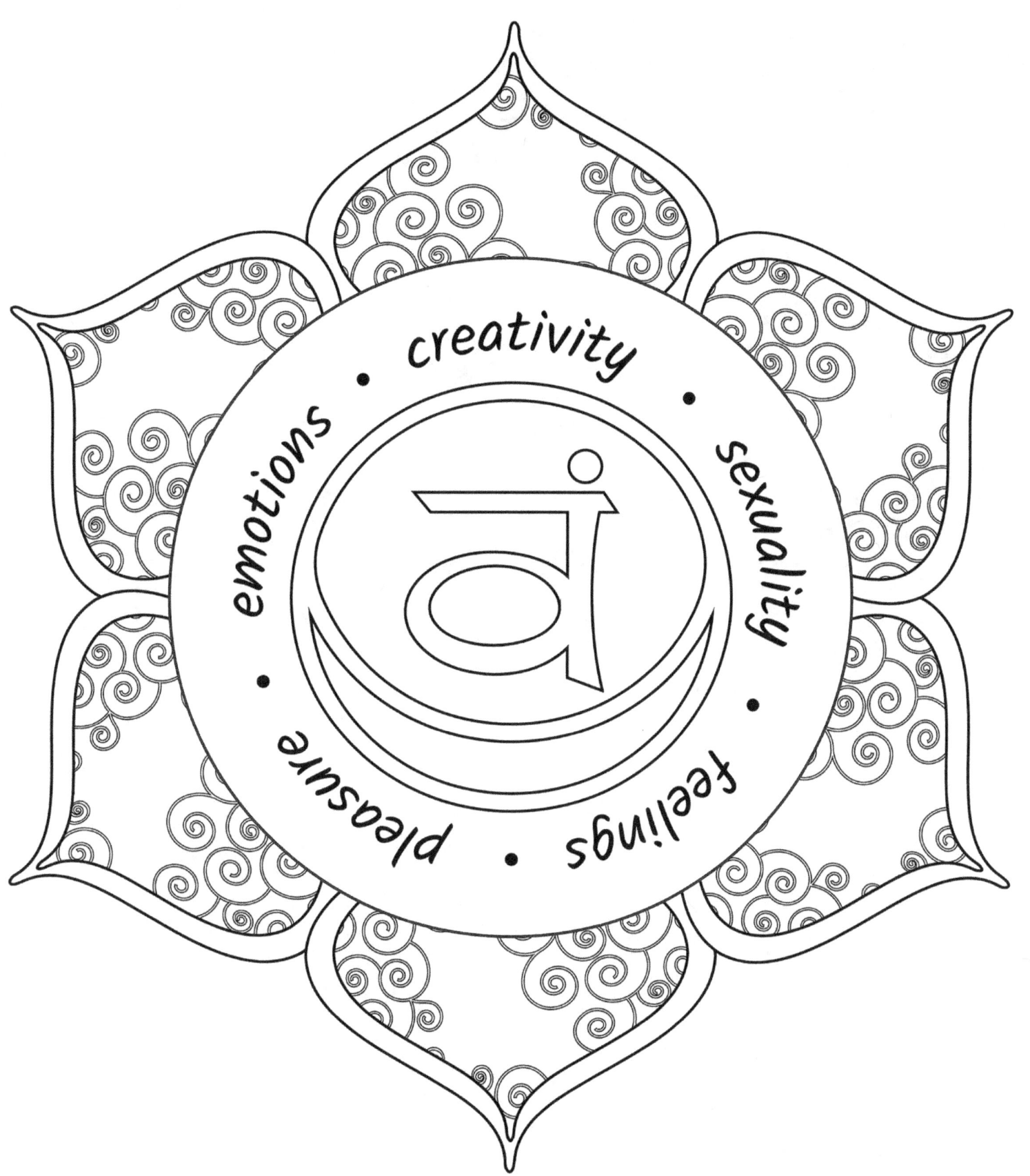

Root Chakra Mandala

The root (1st chakra) is located at the base of the spine. It provides the foundation on which we build our life representing safety, security, and stability. Imbalanced attributes would be scattered energies, anxiety, and fear.

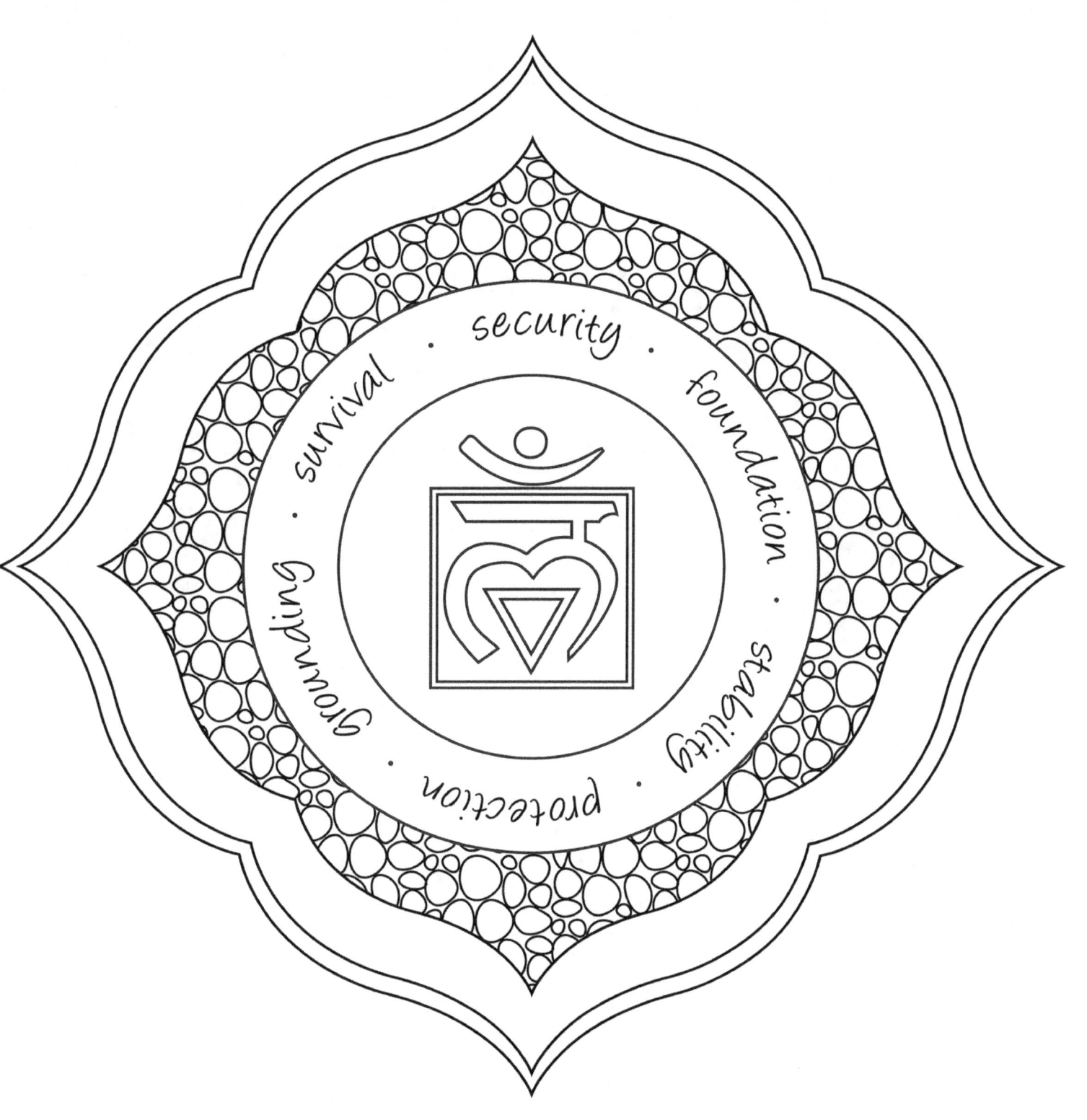

Meditation Chakra Centers Mandala

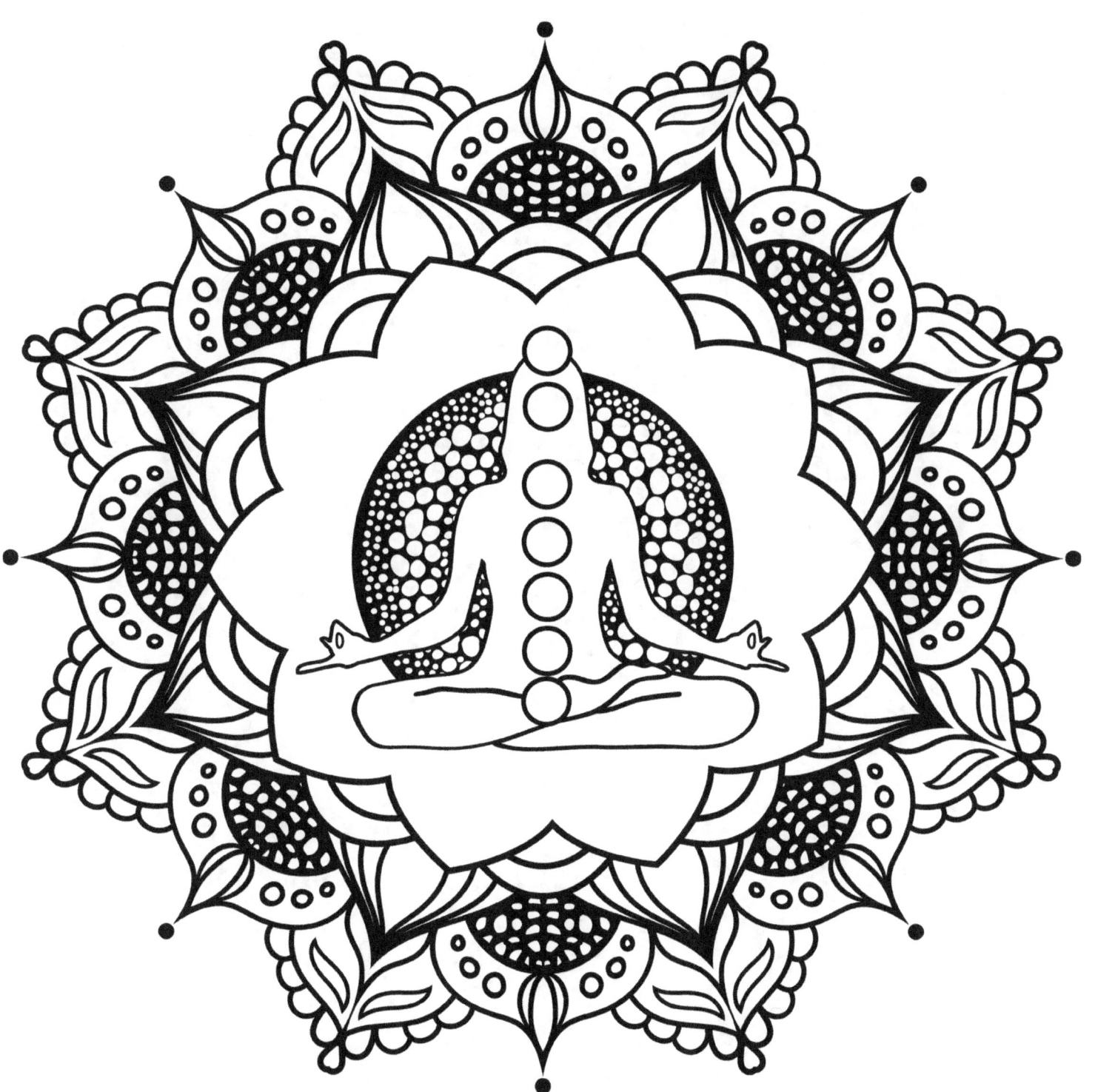

Dream Catcher Mandala

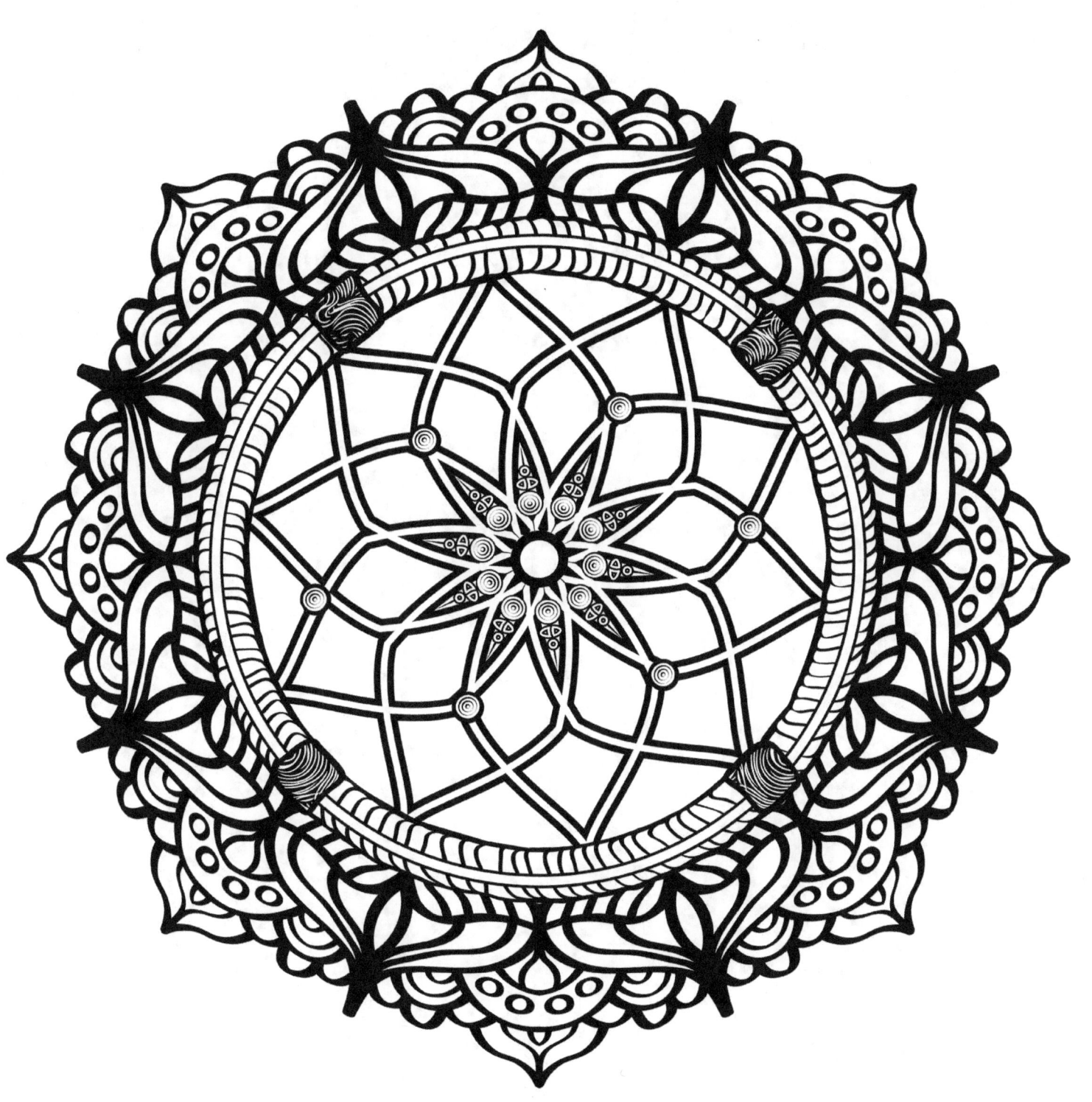

Mermaid Mandala

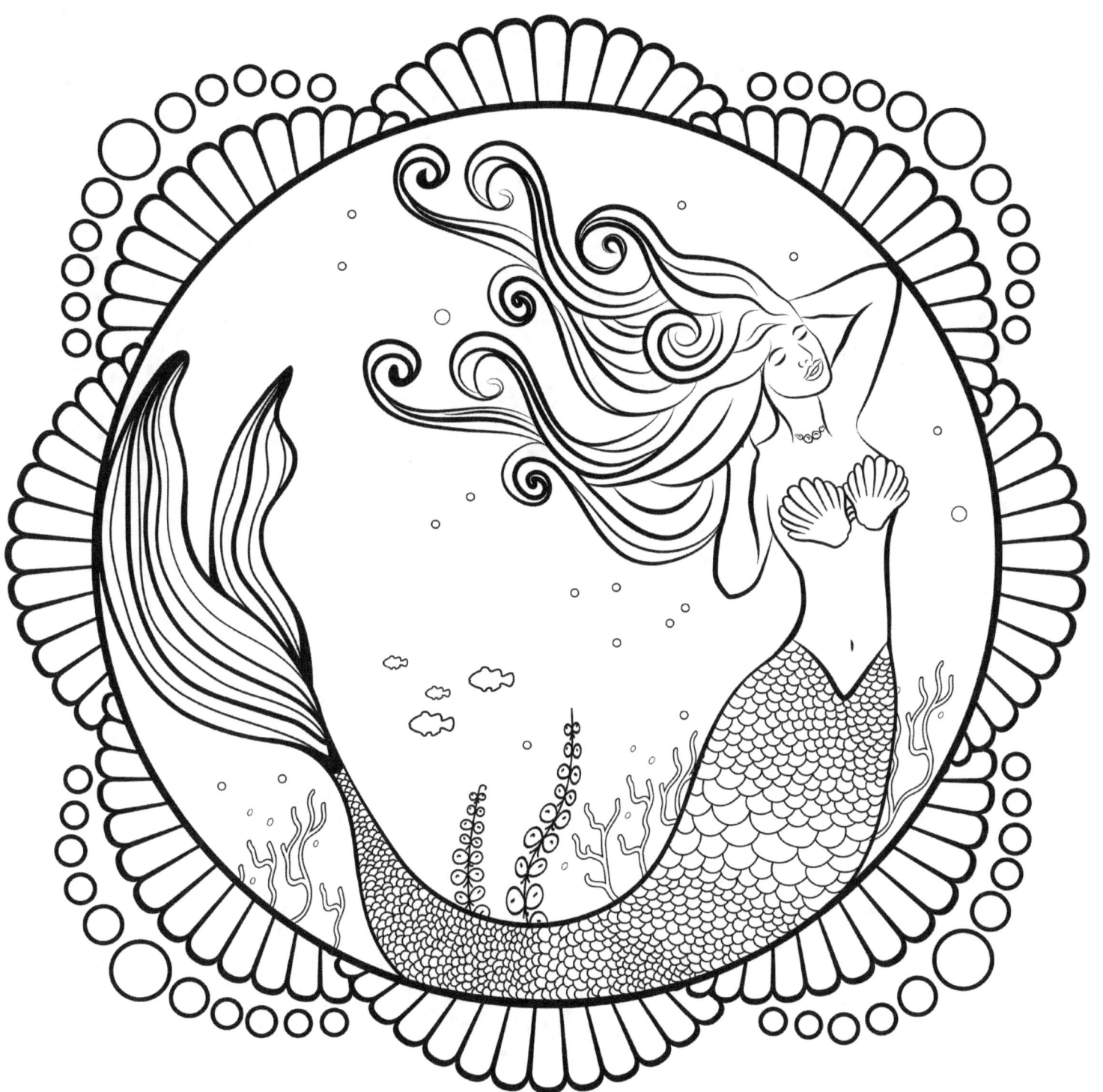

Ornate Flower Mandala

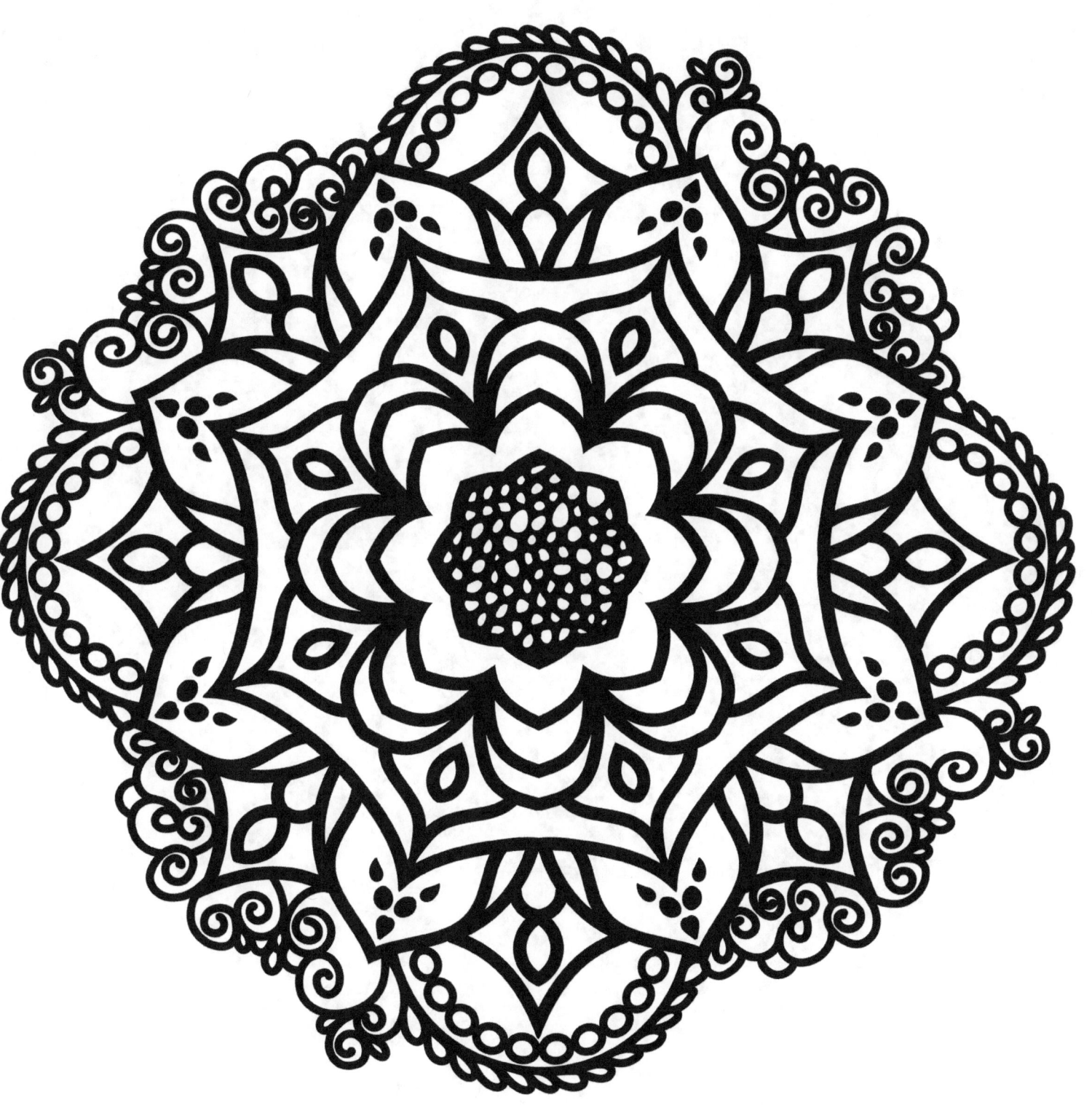

Heart Mandala

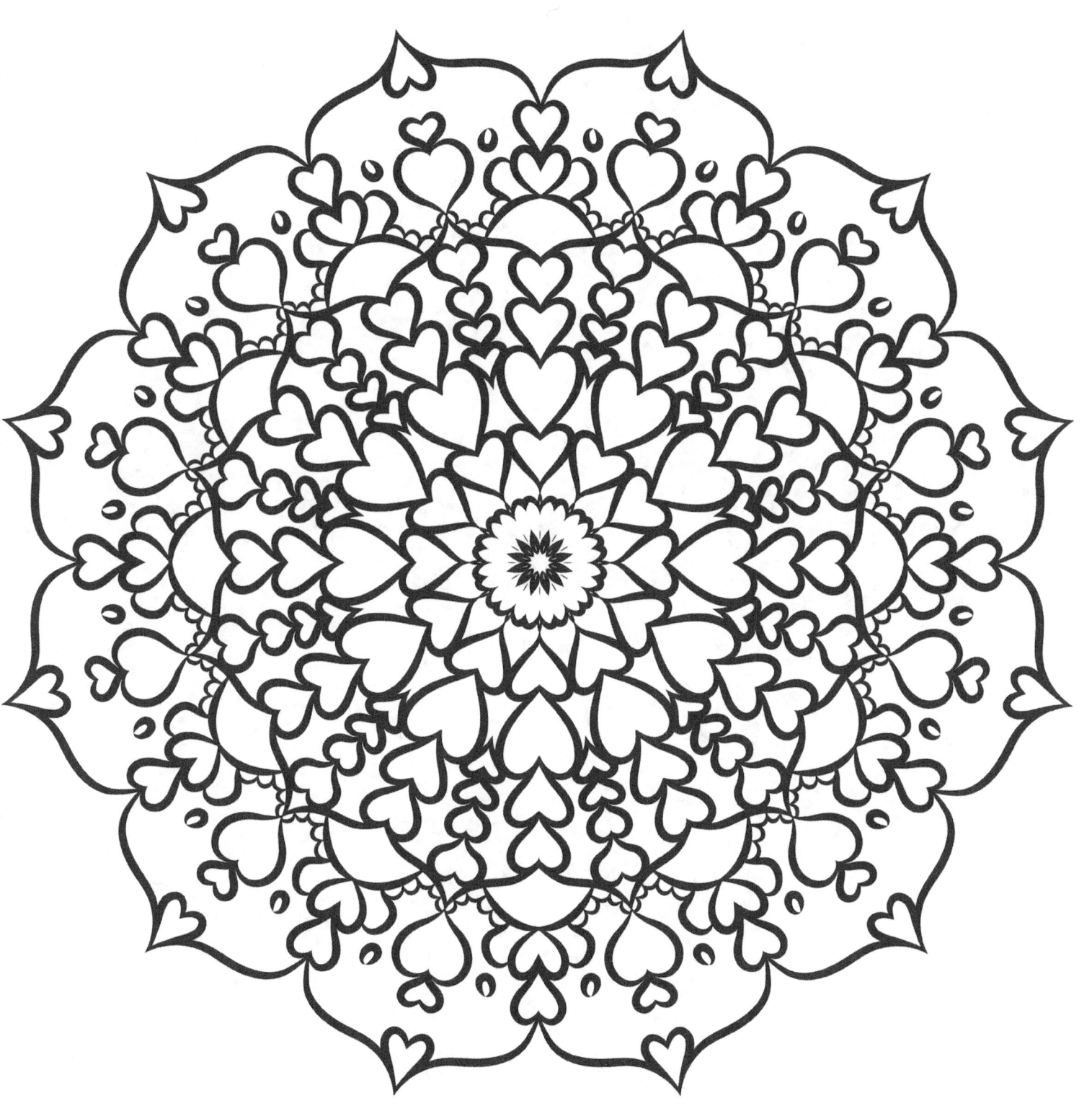

Ornate Mandala

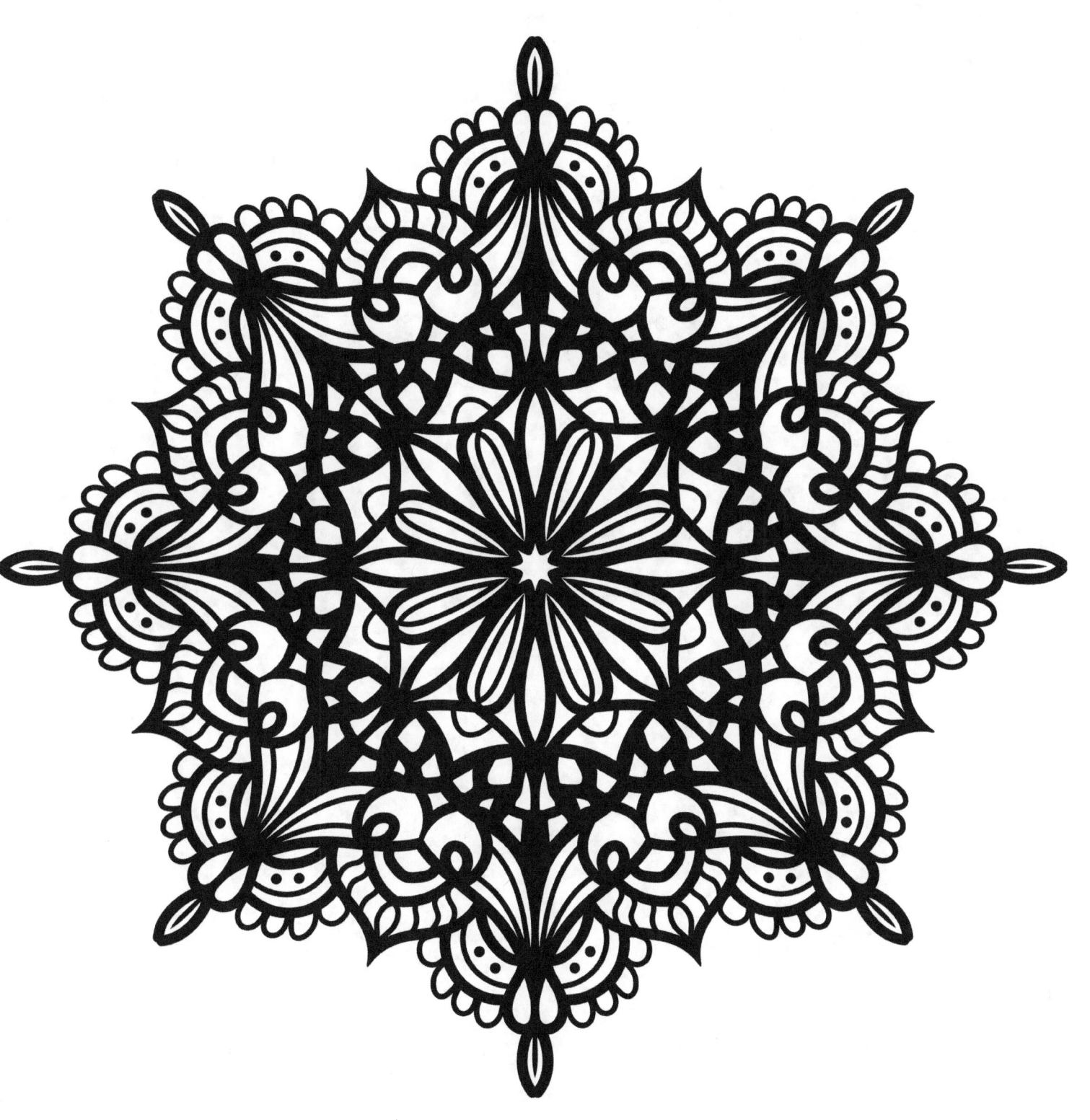

Flower Mandala

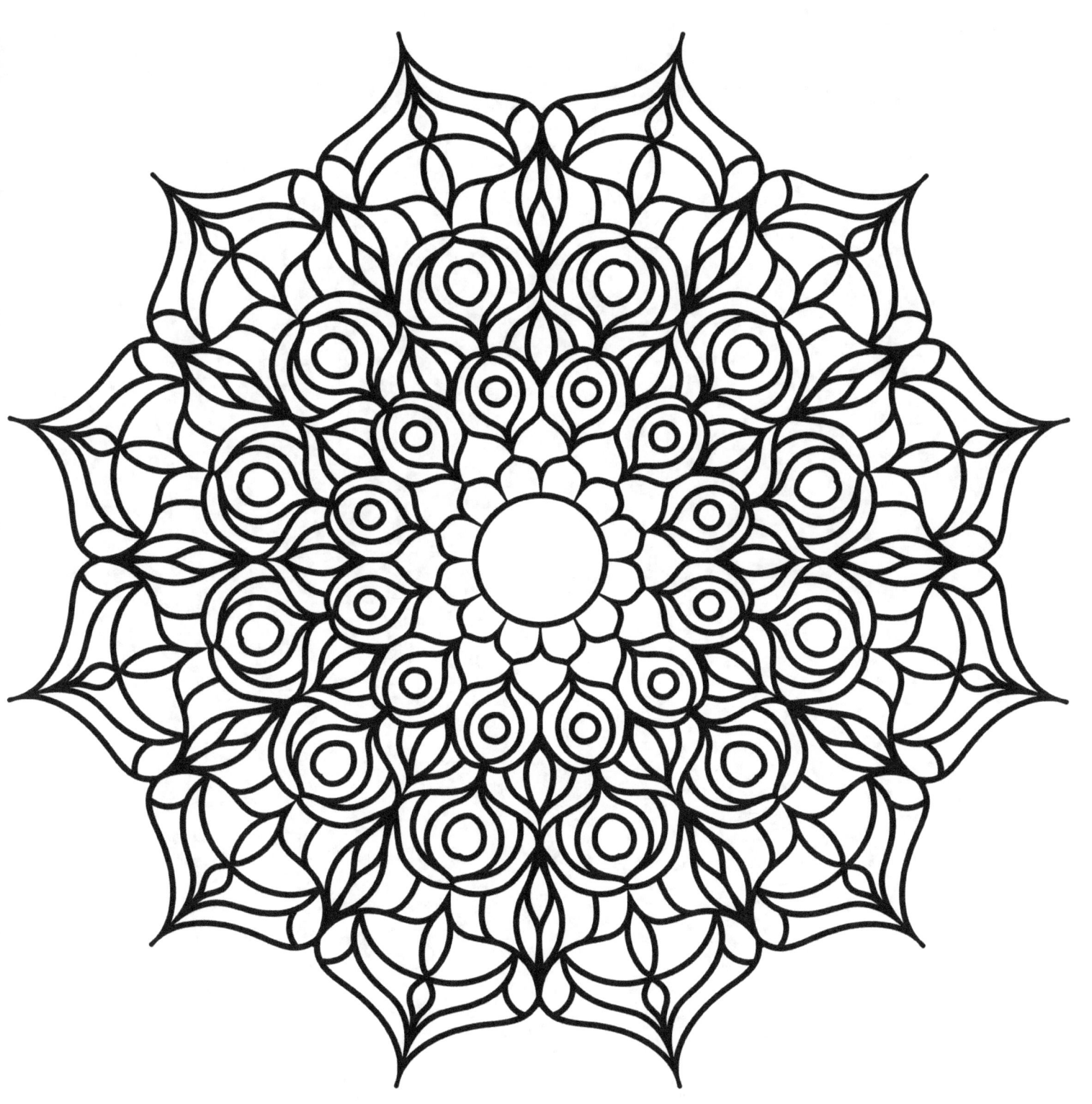

Celtic Mandala

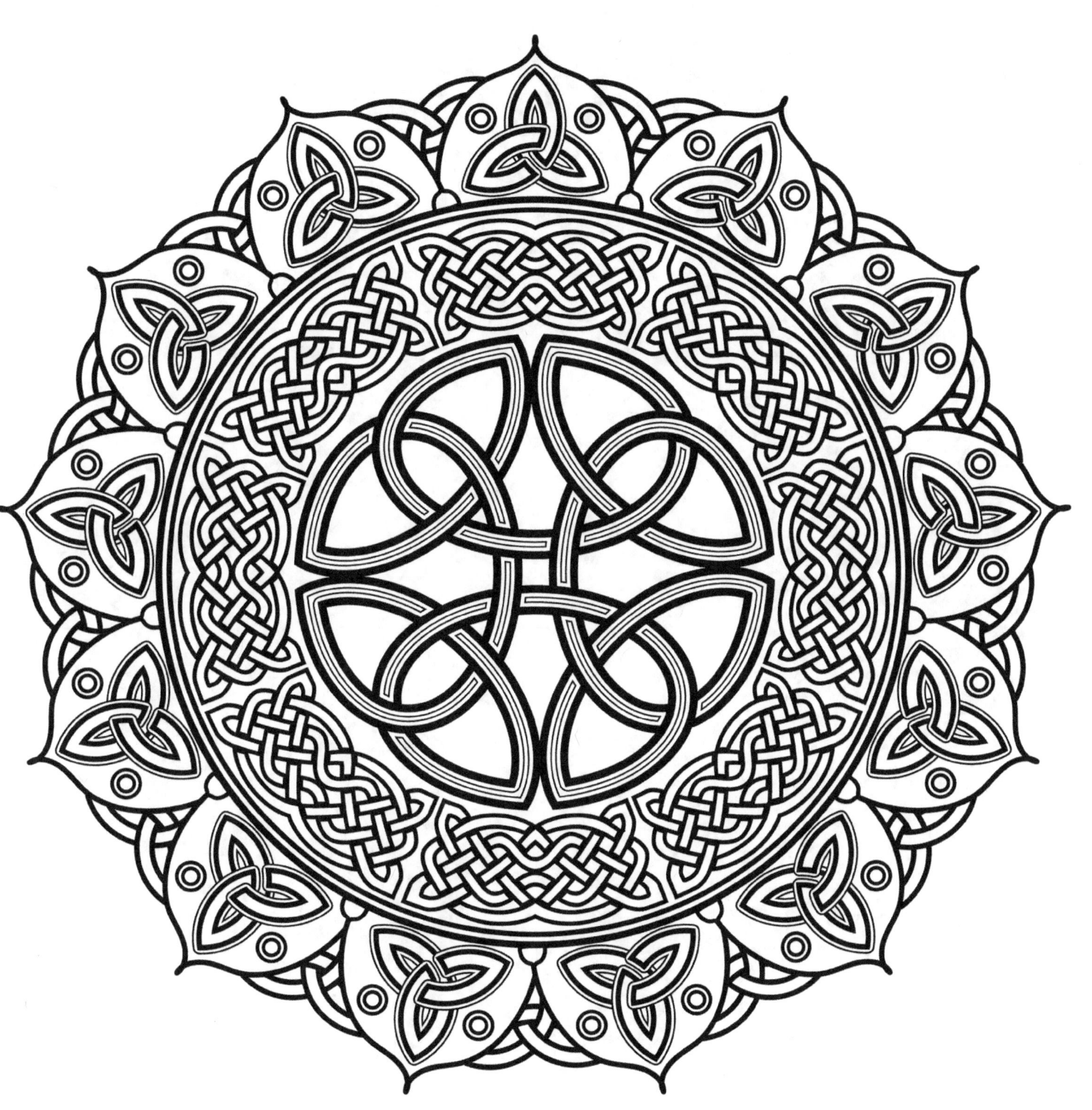

Ornate Lotus Mandala

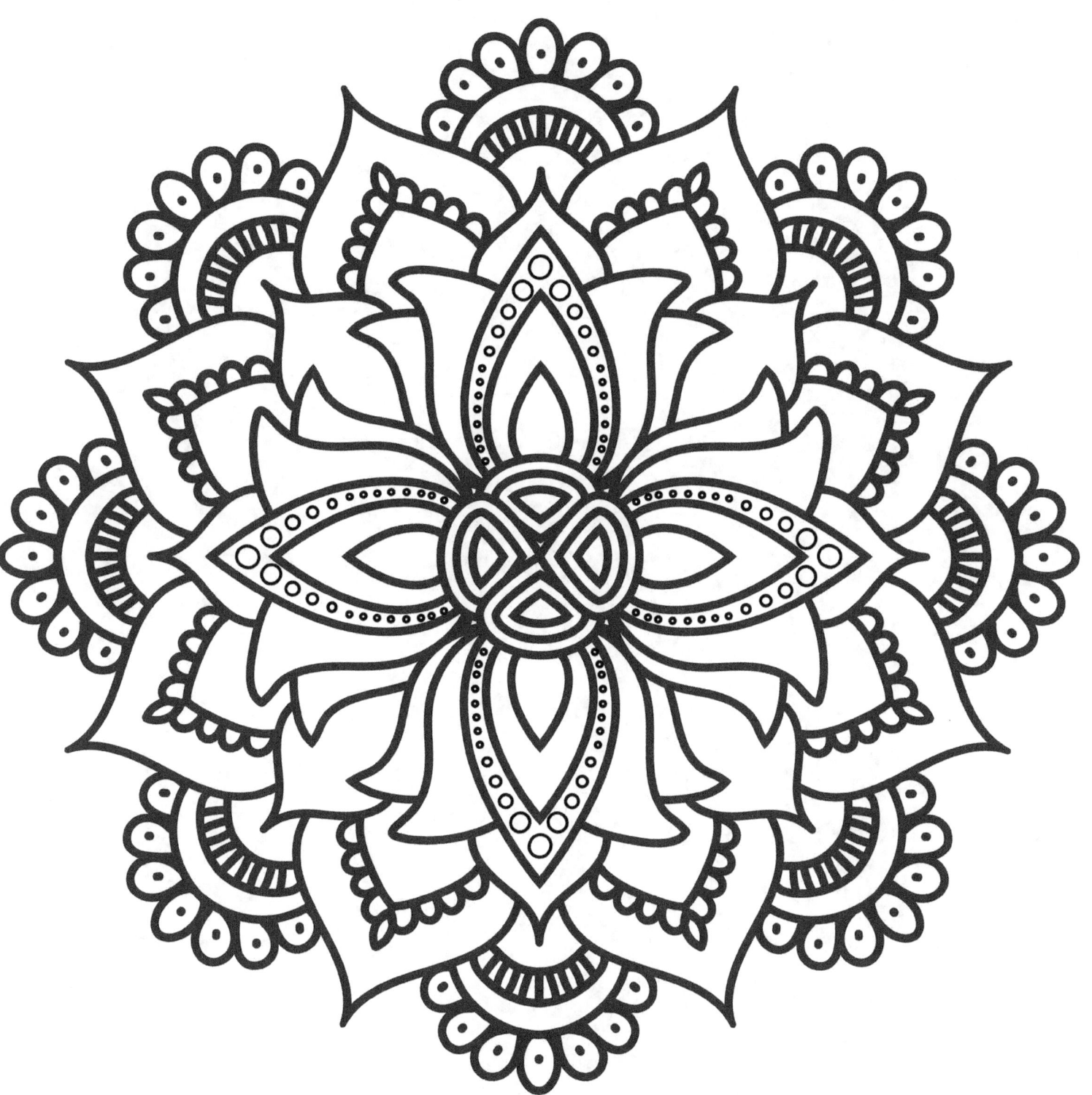

Yin & Yang Mandala

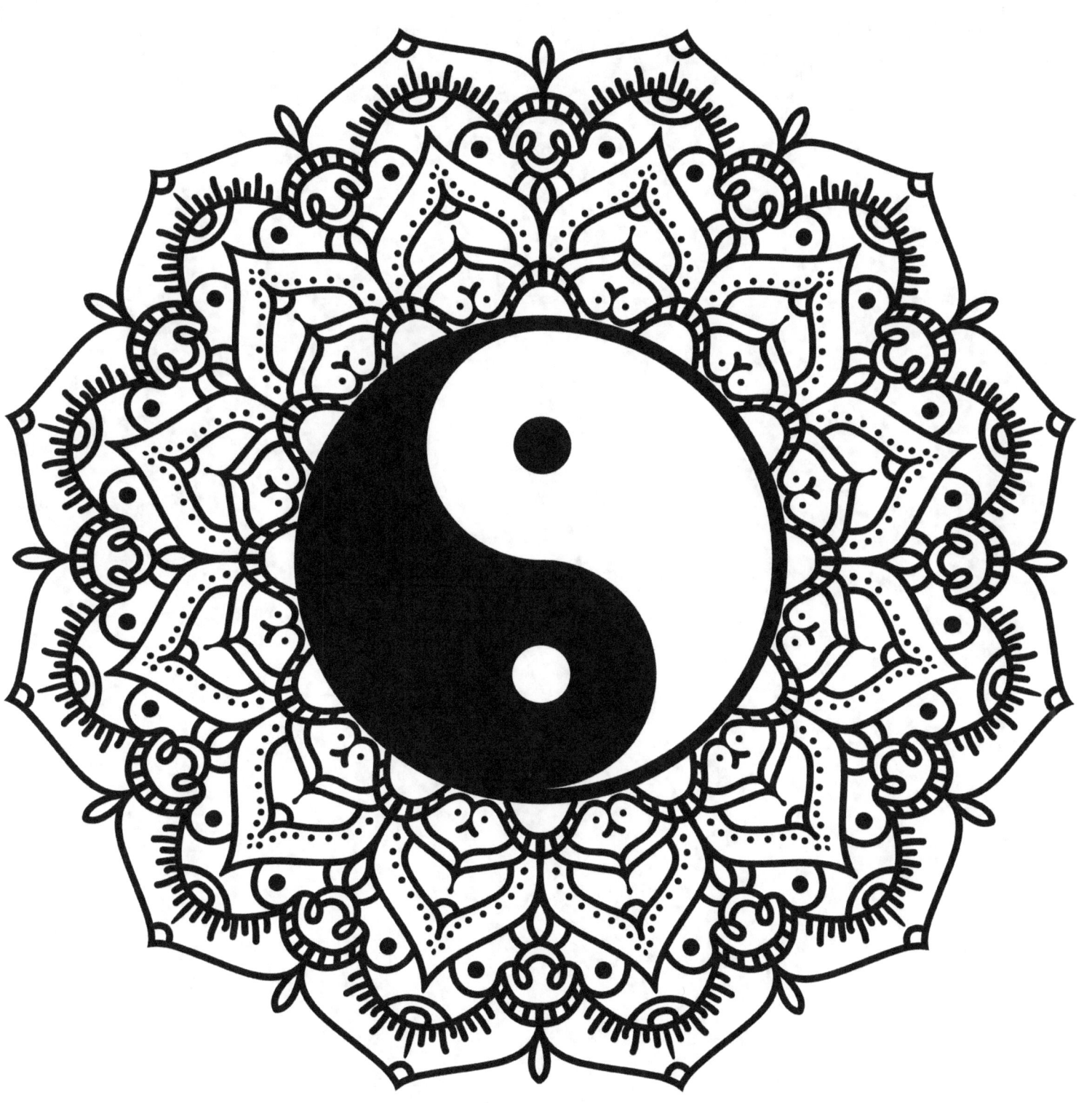

Ornate Star Flower Mandala

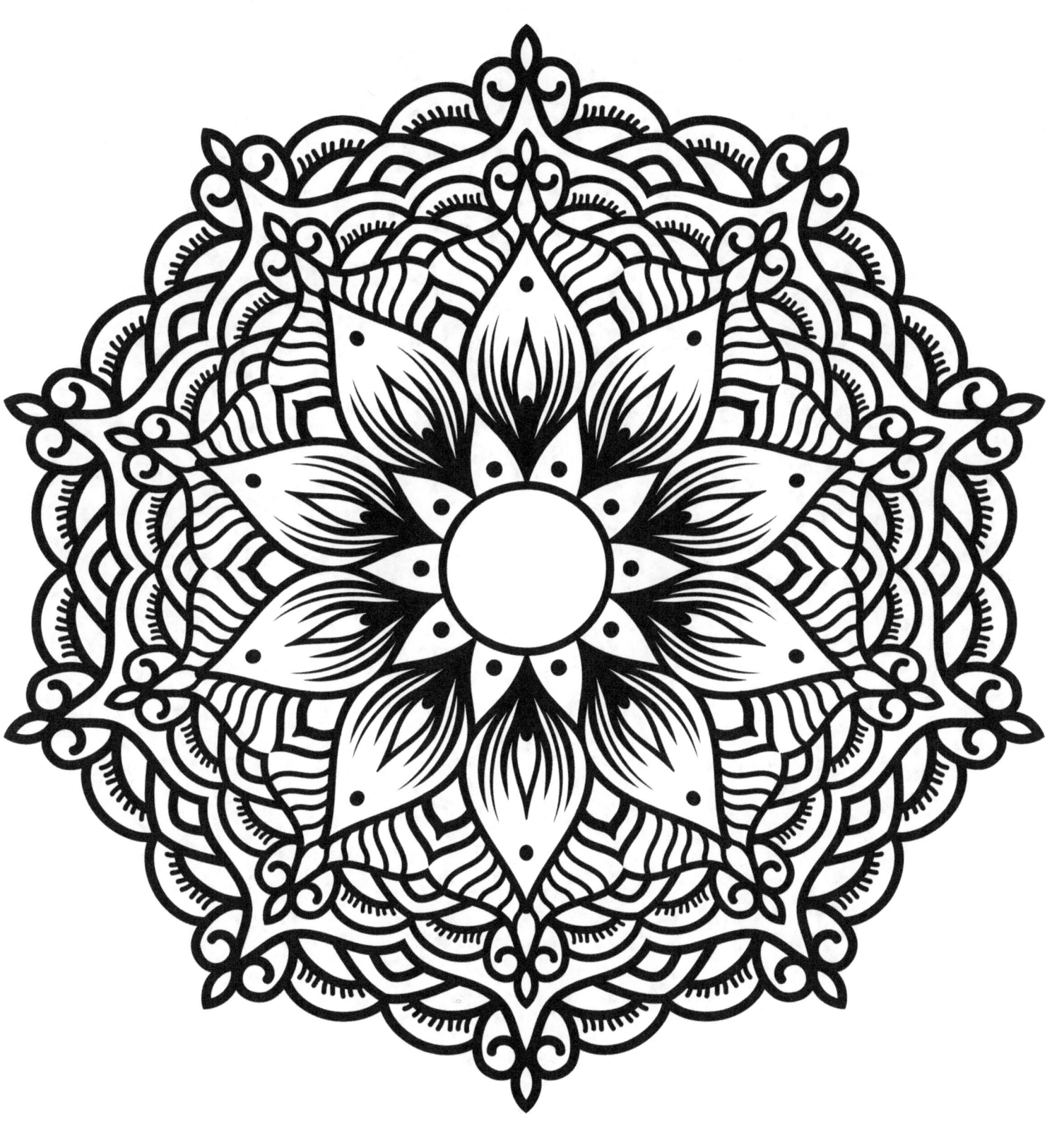

Native American Mandala

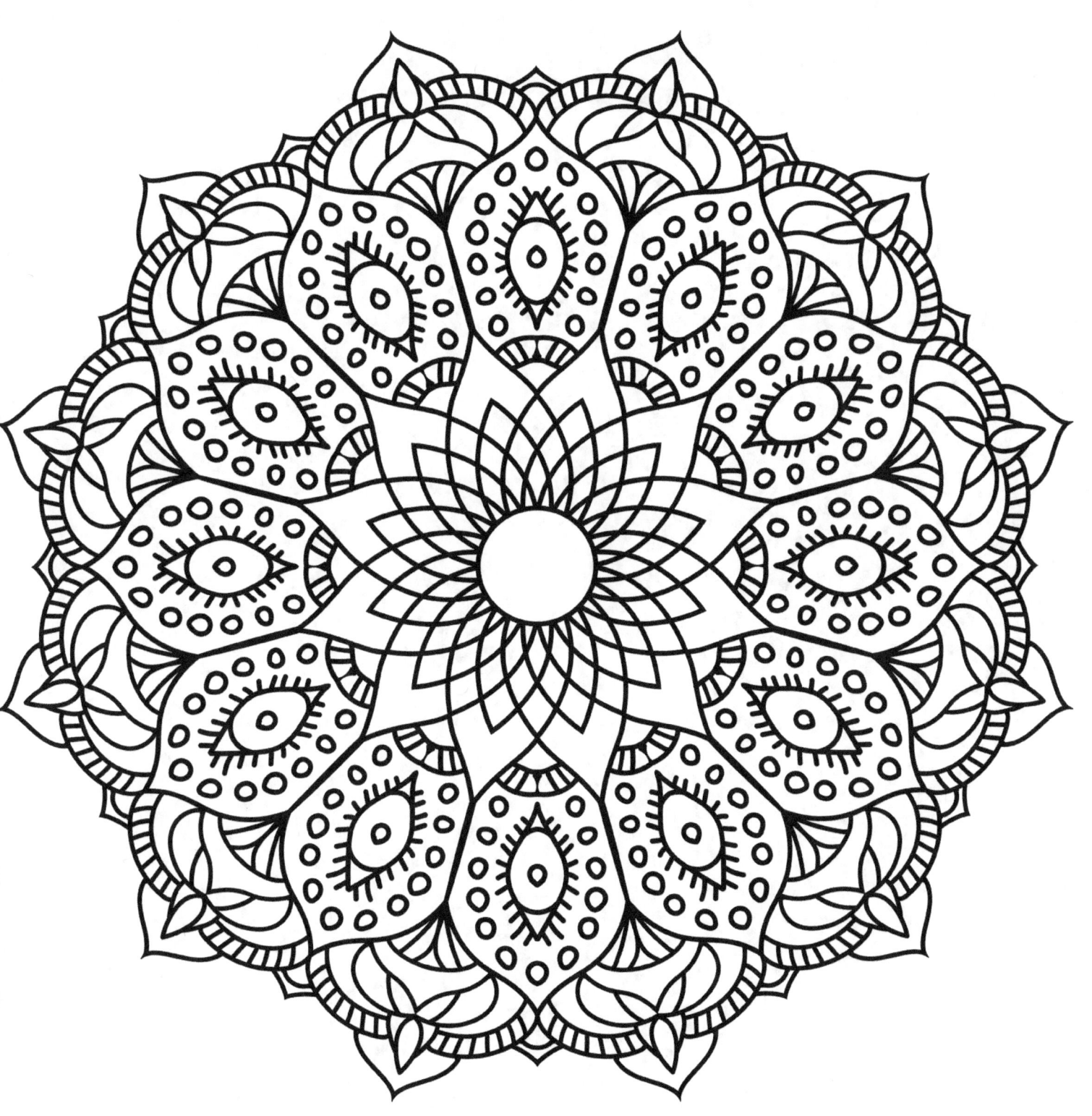

Peace Mandala

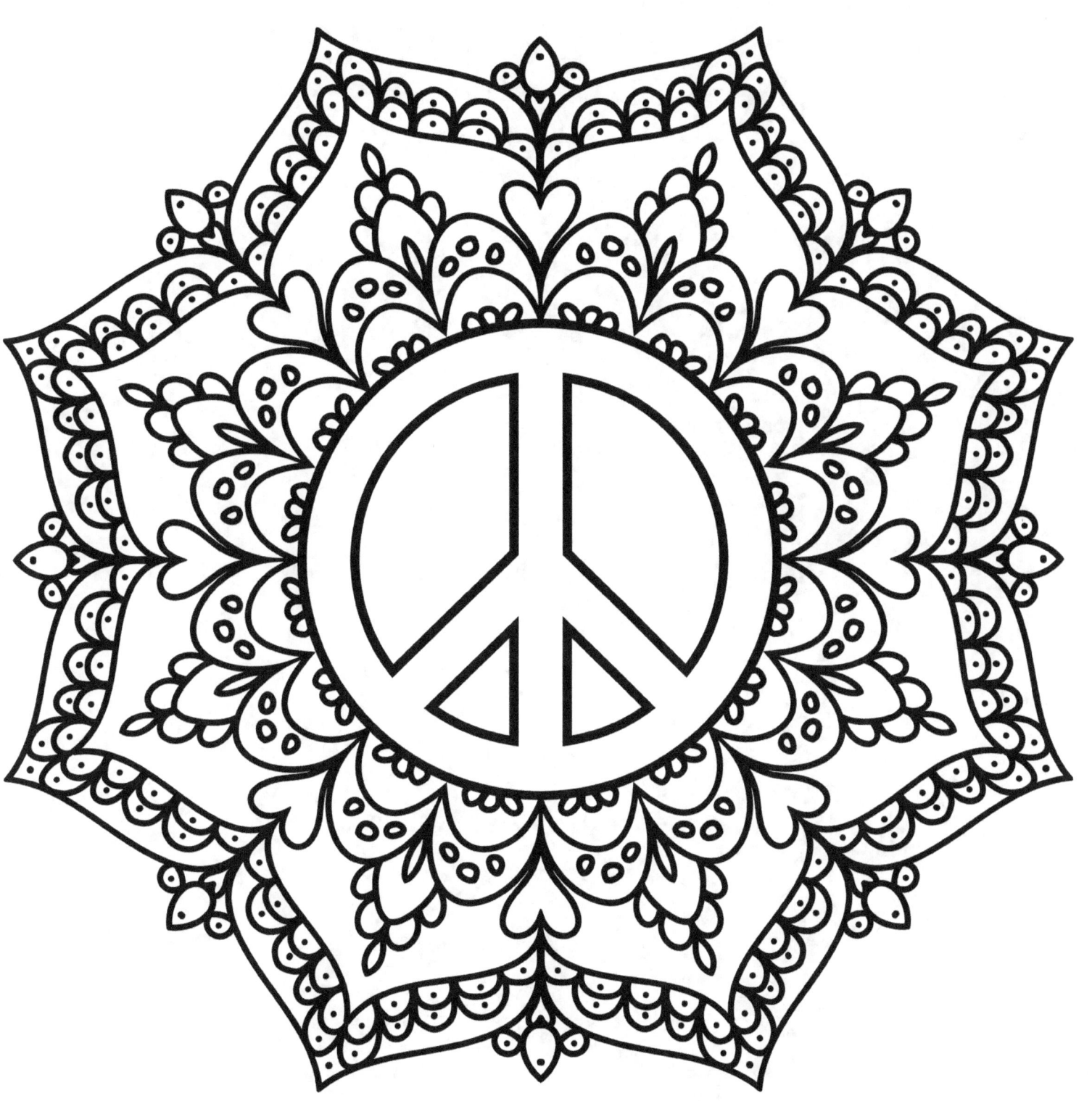

Sand Dollar Mandala

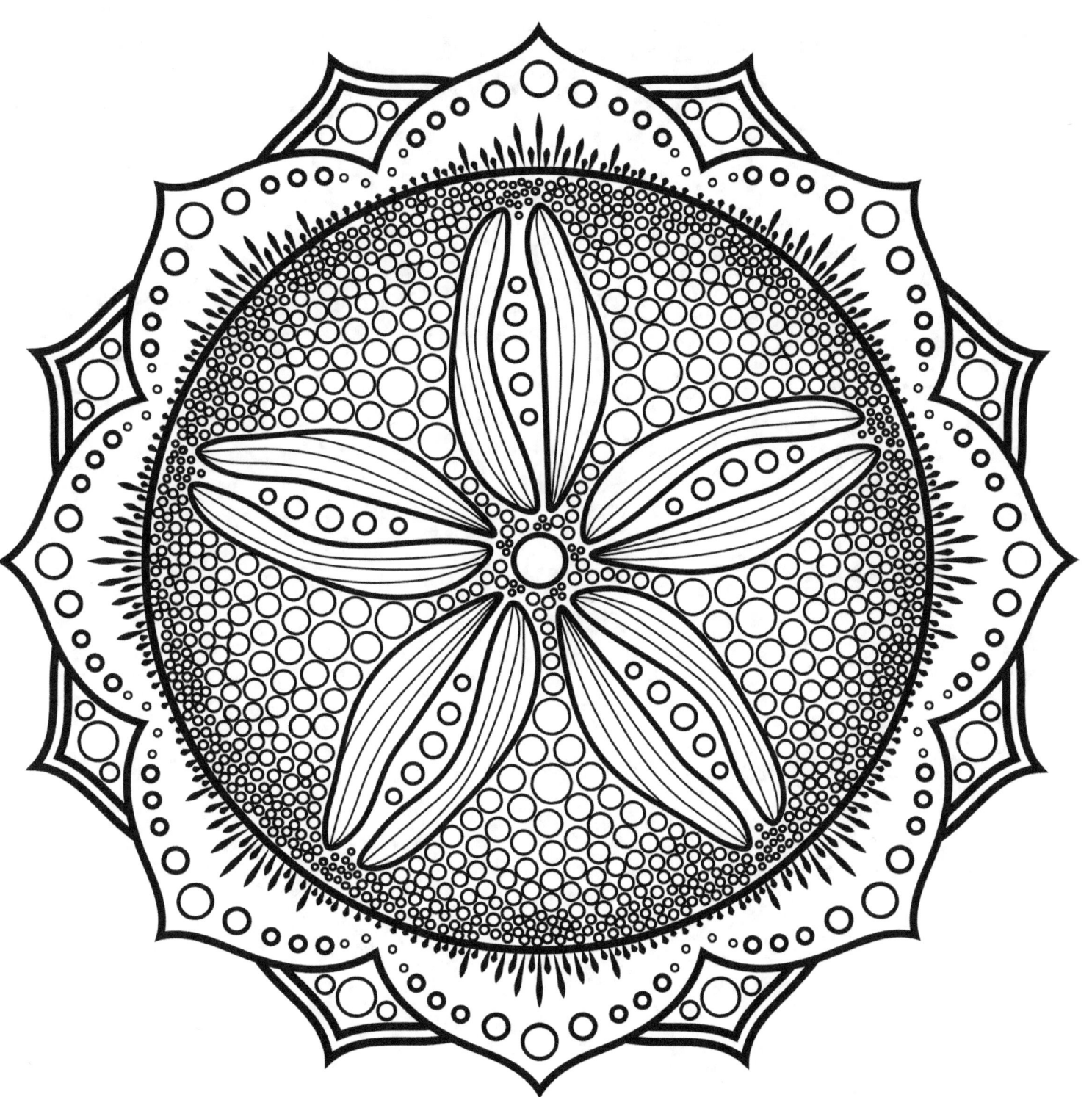

Earth Element Mandala

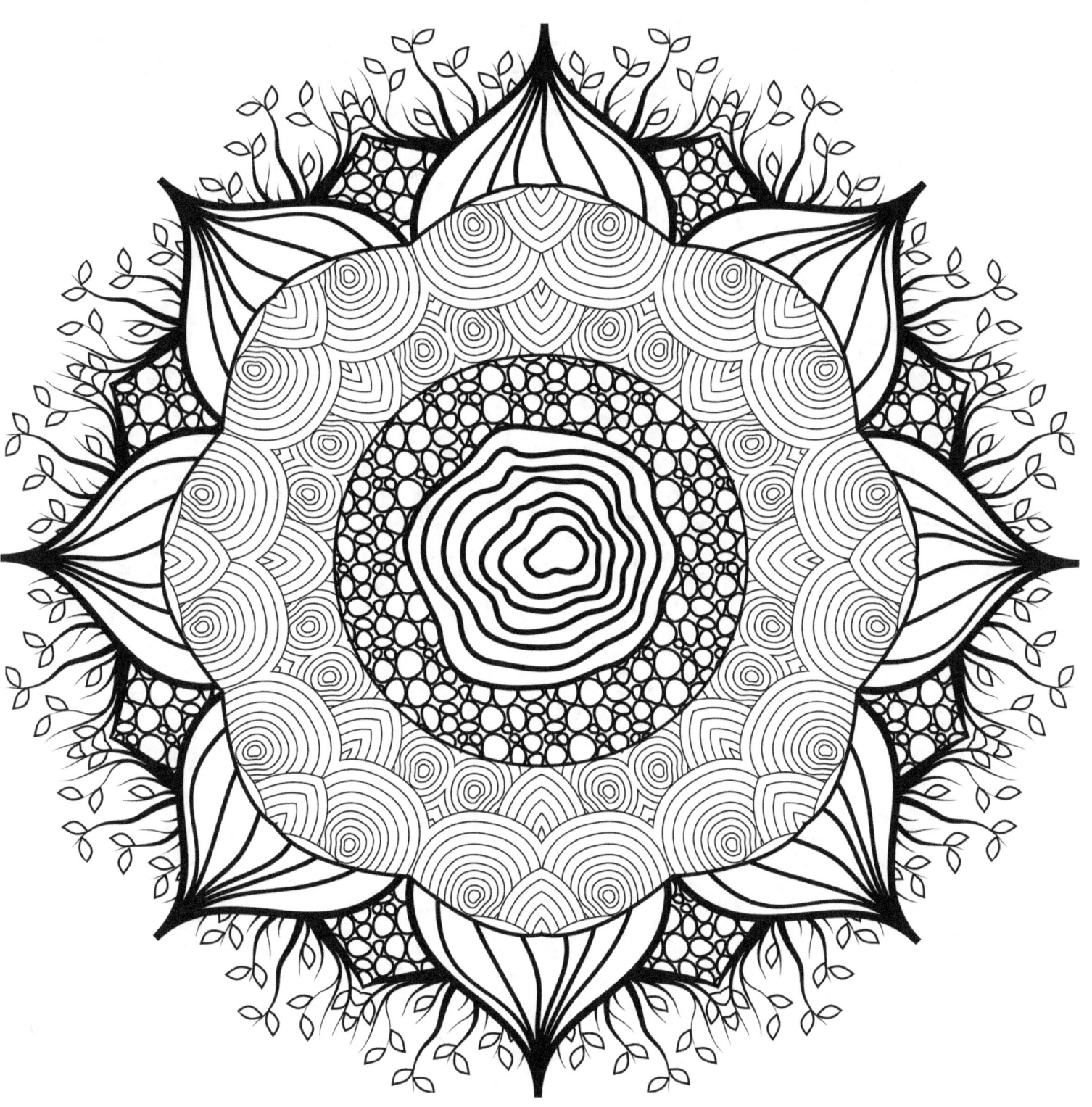

Water Element Mandala

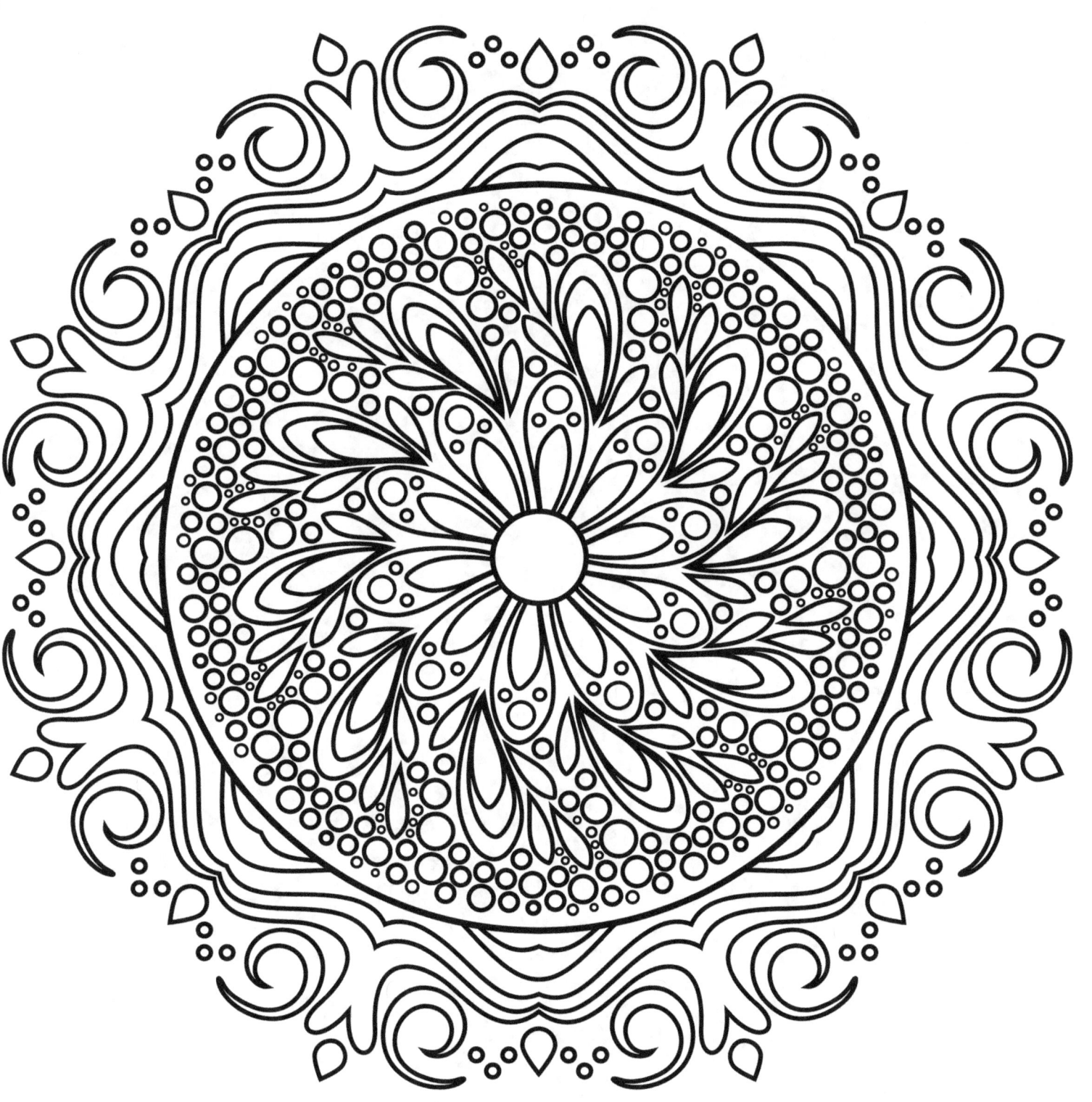

Air Element Mandala

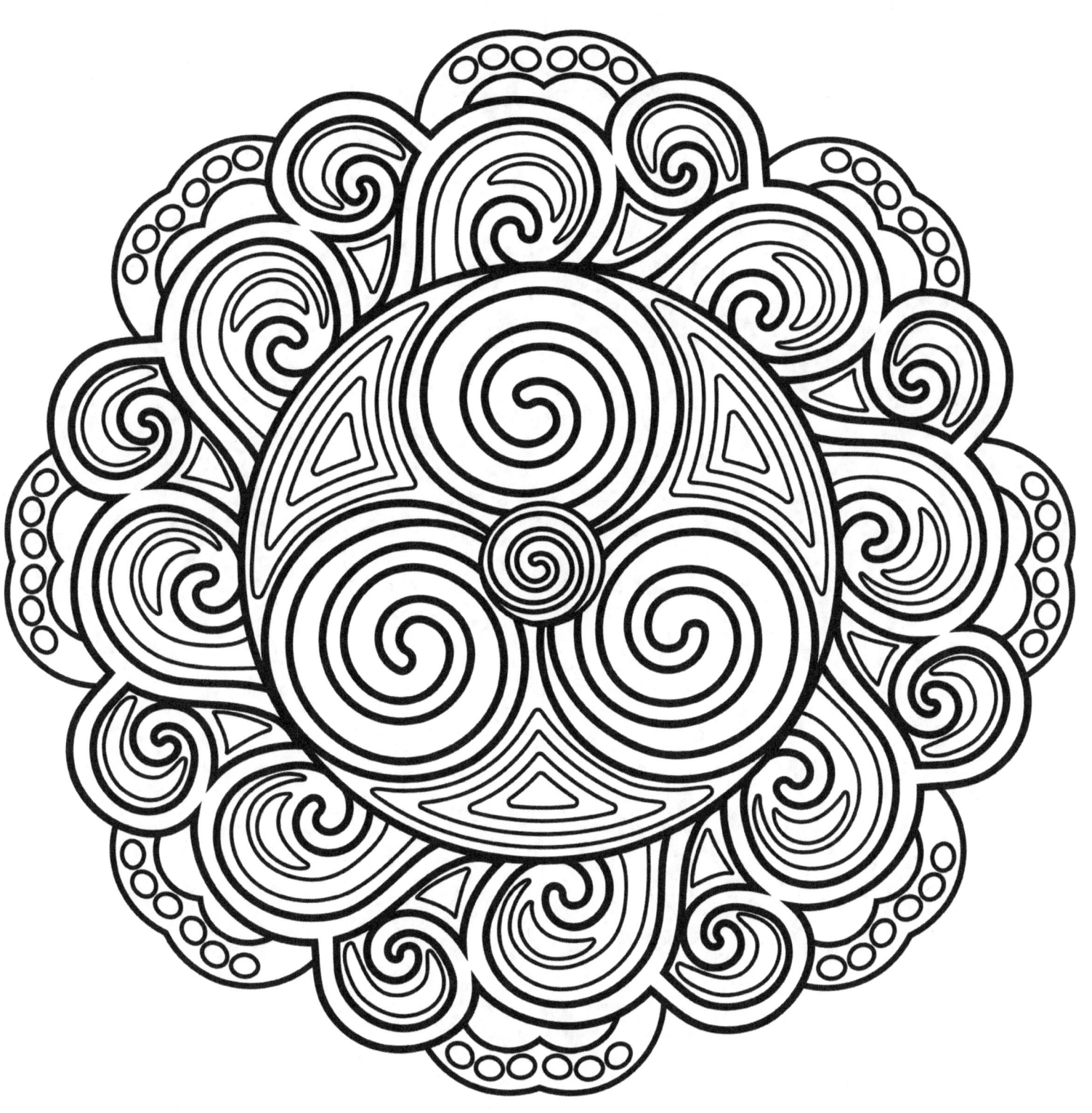

Fire Element Mandala

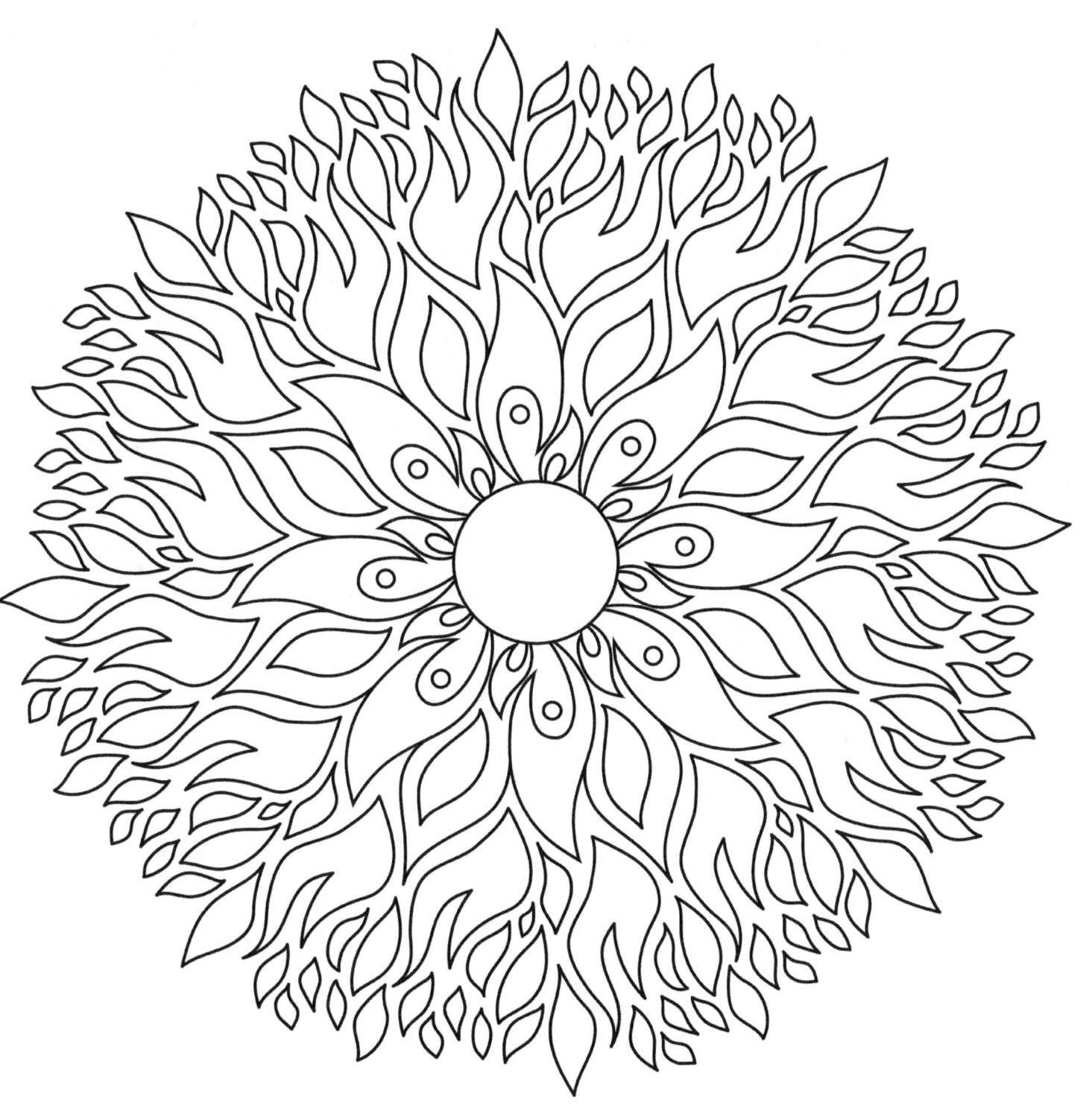

www.ingramcontent.com/pod-product-compliance
Lightning Source LLC
Chambersburg PA
CBHW081446220526
45466CB00008B/2532